Ma-Des-894

STARTER GIIDES

Painting in WATERCOLOURS

First published in the UK in 2006 by New Holland Publishers (UK) Ltd London • Cape Town • Sydney • Auckland

Garfield House, 86–88 Edgware Road, London W2 2EA www.newhollandpublishers.com

80 McKenzie Street, Cape Town 8001, South Africa

Level 1, Unit 4, 14 Aquatic Drive, Frenchs Forest, NSW 2086, Australia

218 Lake Road, Northcote, Auckland, New Zealand

- © Copyright in this edition 2006 by New Holland Publishers (UK) Ltd
- © Copyright of the English text 2005 by

Barron's Educational Series, Inc.

Original title of the book in Spanish: Pintura a la Acuarela

© Copyright 2004 by Parramon Ediciones, S.A.
Exclusive World Rights
Barcelona, Spain
A Grupo Editorial company

All rights reserved. No part of this book may be reproduced, stored in a retrieval system, or transmitted in any form or by any means, electronic, mechanical, photocopying, recording or otherwise, without the prior written permission of the publishers and copyright holders.

ISBN 1 84537 304 9

10987654321

Editorial in Chief: Maria Fernanda Canal

Editor: Tomàs Ubach

Editorial and Graphic Design Assistant: Maria Carmen Ramos

Text: Gabriel Martin Roig

Exercises: Almudena Carreño, Mercedes Gaspar, Gabriel Martin, Esther Olivé de Puig, Esther Rodriquez, Oscar Sanchis

Series Design: Toni Ingles

Photography: Studio of Nos & Soto

Layout: Toni Ingles

Production Director: Rafael Marfil Production: Manuel Sánchez

Acknowledgments

Our thanks to the Escola D'Arts i Oficis, of the Diputatión de Barcelona, Enric Cots, Josep Asunción and Gemma Guasch, and students Emilio Clavo, Teresa Galceràn, Meritxell Mateu, Jaume Punti, Beatriz Reboiras, and Jordi Vila for their support and collaboration in carrying out the exercises in the "Student Work" section

Printed in Spain

TABLE OF CONTENTS

- 8 Watercolour paints
- 10 The best brushes
- 12 Watercolour papers
- 14 Suggestions for a basic palette
- 16 Basic principles of painting with washes
- 18 Flat washes and washes with gradations
- 20 Mixes and gradations from one colour to another
- 22 Painting on a dry surface
- 24 Painting skies
- 25 Starting with the placement of shadows
- 26 Wet technique

30

- 28 The importance of the white paper
- 29 Painting by stages

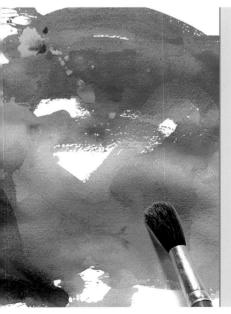

PRACTICAL EXERCISES

- 32 Interior with monochrome wash
- 35 Mastering washes
- 36 Painting a landscape with two colours
- 39 Mixing two colours
- 40 Still life with primary colours
- 43 Mixtures using wet technique
- 44 Rural scene with flat colours
- 47 Incorporating line tracing in watercolours
- 48 Still life with dry technique
- 51 A brief catalogue of textures and effects
- 52 Painting transparent objects: glass bottles
- 56 Student work
- 58 Representing water with wet and dry techniques
- 61 Spontaneous effects with a wet brush on wet paper
- 62 Landscape with atmosphere
- 64 Lessons from the Master: John Constable

The subtlety of WATERCOLOUR

The simplicity of working with watercolours, which require little in the way of materials aside from the paints themselves and gum arabic, along with the purity of the colours, makes this a superb medium for rendering delicate colours and soft tonal transitions. The transparency of the colours is highly attractive, giving watercolour painting a fresh, luminous appearance. The medium is, by its nature, spontaneous, and this quality is clearly visible in the final results.

Watercolour painting is therefore the perfect medium in which to capture nature's subtle nuances of light and tone. The watery transparency of the colours allows the reflective white surface of the paper to shine through, giving the painting a uniquely luminous quality. The relationship between the layers of paint and the whiteness of the paper on which they are superimposed is an indispensable element in obtaining these luminous effects and subtle suggestions of light. As successive washes and layers are applied to the paper, the painting absorbs more light and reflects less. The tone and colour of the painting therefore deepen as work progresses.

Painting with watercolours is both fascinating and fun. Its immediacy allows for an unusual degree of freedom and spontaneity. Though the medium is, by nature, fragile and requires only a modest supply of equipment, it can produce paintings striking for their beauty and sense of presence. All that is required to take advantage of the wealth of visual opportunities offered is for the painter to become familiar with the techniques involved. The combination of mastery and medium will bring perfection well within reach. Though the techniques used in watercolour painting do not pose major problems for the professional painter, for whom they are almost intuitive, they may represent a considerable challenge for the novice.

This book has been designed to introduce watercolour techniques to those who study and love painting and are just beginning to discover its secrets. It is intended to provide a simple, solid foundation, instilling confidence when proceeding to work in this unique medium.

MATERIALS and

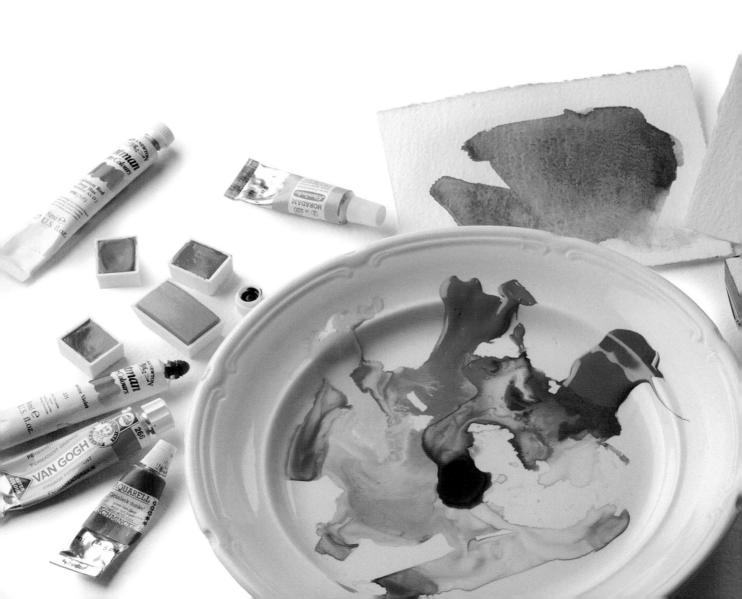

TECHNIQUES MATERIALS and TECHNIQUES

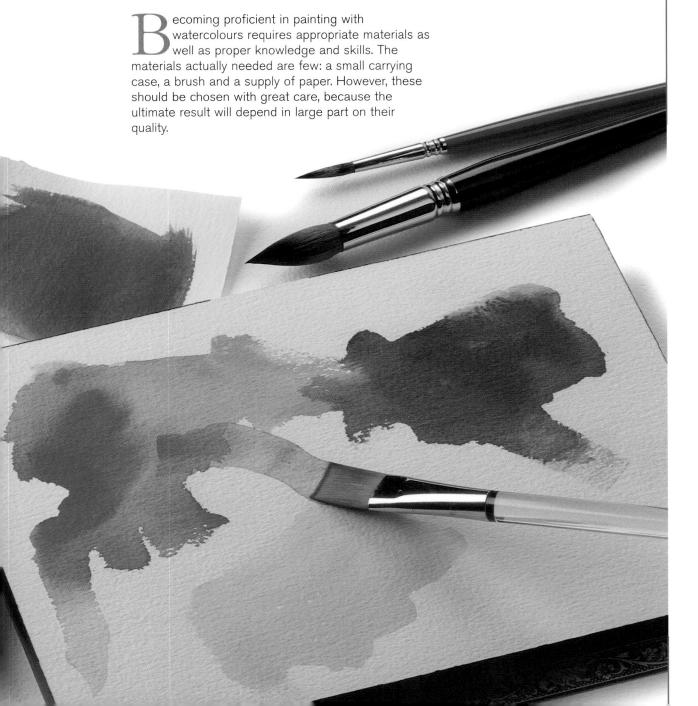

SOLID AND TUBE WATERCOLOURS

WATERCOLOUR

WATERCOLOUR

Paints

Watercolour paints may be purchased in three forms: solid, liquid and paste. Liquid watercolours are sold in bottles; solid watercolours are generally sold in sets, though you may also find them sold individually; and the paste variety is sold in tubes.

Avoid watercolours that school pupils use

Watercolours can be found in many forms and in a wide range of quality.

Differences in quality depend on two factors: the quality of the pigment used and the degree of concentration of pigment in the paint. The most inexpensive watercolours, sold as paints for school pupils, should be avoided because they greatly limit the possibilities provided by medium-quality paints.

Solid watercolours

Solid watercolours generally come in rectangular plastic or metal boxes, though you may also find them singly. Colour is extracted from solid paints by rubbing them gently with a wet brush. The wetter the brush, the lighter the resulting tone. Solid watercolours are appropriate for painting small scenes and are convenient for outdoor sketching.

This box of 12 colours is designed for outdoor painting. In addition to assorted colours of solid paints, the box includes a sponge, a brush, a water bottle and a small container in which to place the water when working.

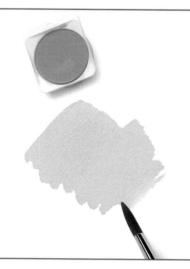

The round variety of solid watercolour paints has very little pigment and is of low quality. The washes produced by this type of paint are overly transparent and lack intensity.

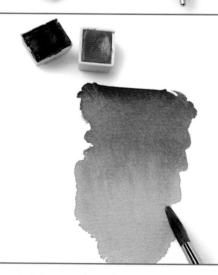

Solid watercolours for professionals have a more creamy consistency and contain a greater concentration of pigment. They can produce intense washes and are ideal for outdoor work.

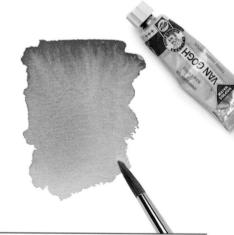

Tube paints are also excellent. Their creamy consistency and their ability to dissolve immediately in water make them appropriate for large formats painted in a studio setting.

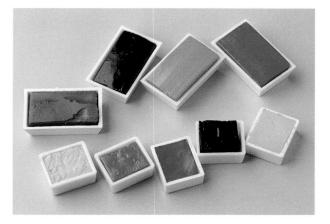

High-quality solid paints are the most practical option when the painter is mobile.

Tip

When solid paints are used for the first time, they should be moistened with a little water and allowed to absorb the water. This makes it easy to extract the colour from them when painting.

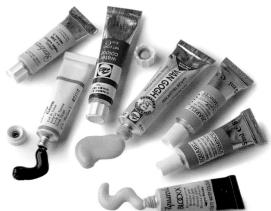

Painting outdoors

Solid watercolours are conveniently laid out in a single small box. This, and the fact that the top of the box can serve as a palette, makes them the most practical option if the artist wants to change locations while painting. Solid watercolours are ideal for making outdoor landscape sketches.

Tube paints

Tube paints are

style.

useful for an already

experienced painter who wants to work in a more personalized

Watercolours in tubes can be purchased in varying sizes and by individual colour. They are moist and creamy, and flow onto the palette when a little pressure is applied. Because they are more fluid than solid paints, tube paints are preferable when mixing paint in large amounts. Because they contain more glycerin, they also dissolve more easily than hard paints.

Liquid paints

These paints, which provide vivid colours, come in plastic or glass containers and are ideal for graphic work and illustration. They work well for creating areas of uniform colour because they provide consistency in tone when diluted. The main problem with liquid paints is that their intensity of colour makes them less suitable for mixing.

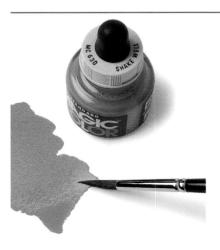

Some liquid watercolours are very similar to gouache. These are not recommended for all-purpose painting, though they are good for final retouching. Their colour is intense and the washes they produce are rather opaque.

Liquid watercolours are like ink, in that the texture of the pigment is barely perceptible. The colours are brilliant and have great colouring power. These paints are excellent for illustration.

A tracing made with a watercolour pencil resembles watercolour paint when brushed with water, even though the tracing does not disappear completely.

LIQUID PAINTS AND WATERCOLOUR PENCILS

PAINTING WITH BRUSHES

The Best SHES BRUSHES SHES

The basic qualities to look for in a brush are good water absorption and retention, flexibility, a tendency to regain its initial shape after a stroke and the ability to execute dots or tracings without the bristles spreading. These characteristics vary according to the quality of the materials used to make the brush.

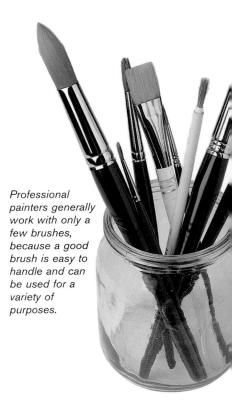

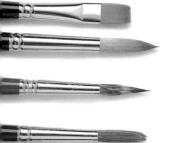

Sable brushes

Squirrel-hair and sable brushes are a good choice. They are spongy, absorb sufficient water and colour, fan out to create a broader swath and regain their shape well. Sable hair extends naturally to a fine point, making possible a high degree of precision in painting delicate details.

Today's synthetic bristles are of high quality and have been treated so that they will quickly regain their original shape.

Brushes made of synthetic bristles

Synthetic-bristle brushes are the least expensive. They approximate, at lower cost, the effect of natural-bristle brushes. However, they absorb less paint and may be somewhat stiff and less pleasant to work with than natural-bristle brushes. The fine-pointed variety are good for detail work.

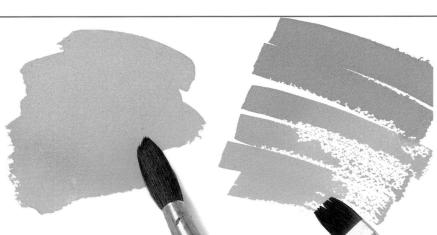

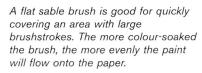

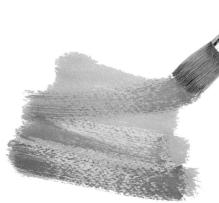

Though bristle brushes are generally used for oil painting, they can also be used in dry-technique watercolour painting. They create a rough, textured brushstroke.

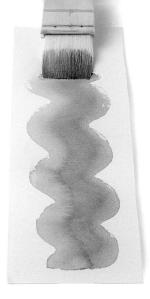

Tip

Once you have available an assortment of brushes, try them out on various papers to see the range of results they are capable of producing.

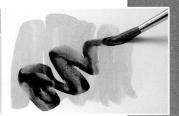

Broad brushes, often referred to as wash brushes, are used to quickly colour large areas.

Ox-hair brushes

Ox hair regains its shape less fully than sable and is not as good for detailed work. On the other hand, it lasts well under extended use and is a good alternative to more expensive brushes. It does not, however, maintain its fine point and is thus less than ideal for detailed work, though it is perfectly adequate in square, flat or wash brushstrokes.

A basic assortment

Watercolour painting does not require a large number of brushes. A single brush of good quality can produce many different types of lines and splotches of colour. Watercolour brushes come in different thicknesses. For simplicity, we recommend the following: three round sable brushes (fine, medium and large), a flat synthetic brush (medium) and two sable wash brushes (one medium, one broad).

Round brushes

The round brush is the classic long, pointed, conical brush that can be swept easily in any direction and makes any type of line, from a fine line, where the brush barely grazes the paper, to a thick one made by applying pressure.

Wash brushes

Wide, flat watercolour brushes are sometimes known as wash brushes. They are designed to hold a large quantity of paint and produce a flow of colour adequate for large washes. By using their edge, one can create sharp, clean line strokes.

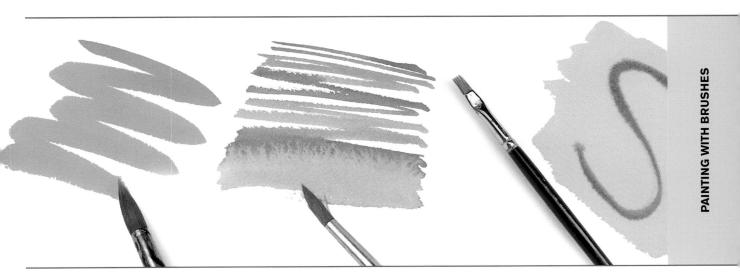

Synthetic brushes should not be dismissed as inferior to natural bristles. They can be of excellent quality, and they retain their stiffness well over long periods. The best brushes for detailed work are those with a round point. Round, finepointed brushes are generally used for lines and details. This is another type of small brush that may be used for painting on a wet surface. Brush strokes on wet paper expand in an irregular way and create a misty effect.

Watercolour Watercolour

Before starting work on a painting, it is wise to do some preliminary tests on the paper that is to be used to see how it reacts to paint.

PAPERS

The type of paper used in painting with watercolours is extremely important. Not all types of paper will be suitable. Only paper with particular characteristics should be used, as the quality of the painting will depend to a great extent on the quality of the paper. The paper's grain, its weight and the texture of its surface are important factors.

Trying out the paper

Most paper responds to paint and colour in slightly different fashion. Before beginning work, it is therefore helpful to make a few brushstrokes on a small piece of the paper to see how it reacts and how long it takes to absorb the water. It is important that the fibres in the paper have a porosity that will absorb water well, and that the paper expands evenly in all

directions and recover its initial shape quickly when it dries.

Grain

Three different paper textures may be distinguished: fine, medium and coarse. Fine-grain paper requires applying greater tension at its edges, dries faster and is often used for

small field sketches or paintings. It allows for clean, sharp lines. It is not, however, the best choice for beginners. Medium-grain paper is preferable because it enables better overall handling. A medium grain makes it feasible to work without requiring rapid, tightly controlled brushstrokes, whereas coarse-grain paper is the type most favoured by the professional. Its slower drying characteristics and rough texture allow the experienced artist to take advantage of advanced watercolour techniques and the relief of its texture brings to the fore the colour in the dips of the surface, while slowing the drying process and making it possible to make corrections if necessary.

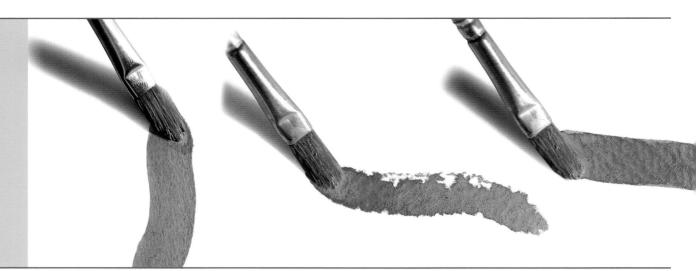

The texture of fine-grain paper is the least rough, enabling precise, sharply defined brush lines.

Medium-grain paper is most suitable for beginners.

Coarse-grain paper is especially intended for watercolours and is most commonly used for large-format painting.

In the past, the watermark indicated the side of the paper that had been treated to serve as the painting surface.

Which side of the paper to use

In the past, only one side of the paper was treated for painting, so it was crucial to be able to distinguish between the two sides. This is no longer the case, and the watermark now serves merely to identify the paper's manufacturer. With certain papers, the coarseness is different on the two sides. This can be a useful feature, offering the painter two different options.

Tip

Also available on the market is Japanese paper, which is handmade from rice and has a spongy texture. Because it is highly absorbent, it does not allow for many corrections. The artist must therefore exercise great care when painting.

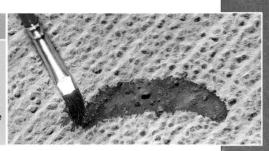

Weight of the paper

The paper's weight is important. A light paper made for drawing will wrinkle and warp under moisture in watercolour painting. The ideal weight for watercolour work is between 250 and 350 grams.

artists use gummed tape or, in some cases, drawing pins for this purpose. Paper that is heavier than 300 grams does not require stretching unless it gets thoroughly soaked. Lighter papers, however, should be stretched to avoid warping and billowing.

Paper that has been wet without being stretched tends to warp.

Stretching the paper

Before undertaking different watercolour techniques, you should learn how to stretch a piece of paper on a wood surface. Stretching keeps colour from pooling on the paper and prevents the paper from wrinkling. Many

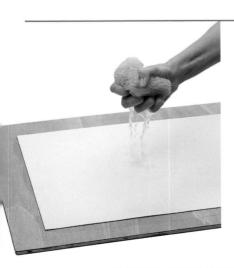

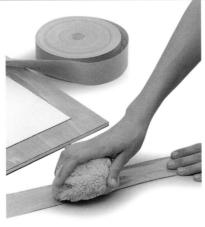

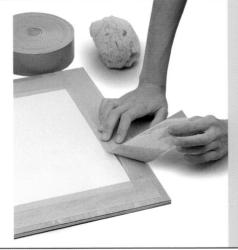

To attach the paper to a support surface, the paper should first be moistened. Before attaching it, the paper should be allowed to expand under the effect of the water for one or two minutes. If the paper is wet, gummed tape should be used to fasten down the edges. The tape can be wetted with a sponge before use. If the tape is applied properly, the paper will show the same degree of tension on all four sides. Once the paper and tape are in place, painting may begin.

Suggestions for A BASIC PALETTE

Watercolour painting does not require having many colours on the palette. Mixtures of seven well-chosen colours can yield any colour desired. Once you gain experience and your technique improves, you may well have the chance to substitute colours or expand the palette.

About colours

Given the availability of a wide range of colours, there is no need to spend time preparing basic mixtures. Moreover, an expanded palette and a profusion of different tones may turn out to be confusing. On the other hand, not blending colours can limit the possibility of achieving nuances and you won't be able to fully

enjoy the fascinating world of colour. You should therefore aim to achieve a varied, carefully chosen palette that allows for a wide array of colours, without being excessive.

A basic selection of colours

A good basic beginner's palette might consist of lemon yellow, ochre, orange, umber, sepia, cadmium red, permanent red, permanent green, emerald green, cobalt blue, ultramarine blue, Prussian blue and ivory black. With these colours, any mixture is relatively easy to achieve, enabling you to experiment and explore. Choosing colours is, of course, a personal matter, but the above colours, which are widely and frequently used, are capable of producing a vast range of tonal mixtures.

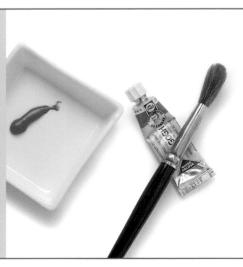

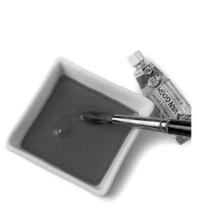

Dip the brush in water and mix water with the paint. If the colour is too intense, add more water.

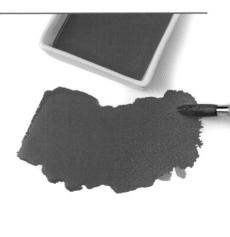

To achieve the proper colour transparency, become accustomed to continually testing the paint on a separate piece of paper before actually applying the colour to the painting.

Tip

Owing to their frequent use, violet and orange, which can also be obtained from mixing, are generally found on the palette of professional artists ready-made, to save time.

Diluting tube paints

ivory

black

sepia

Watercolour paints should be placed on the palette in moderate amounts. Solid watercolours must be diluted substantially and their effect is therefore more watery and less intense. On the other hand, the colour of tube paints on

umber

ochre

the palette is more concentrated and dense than that of solid paints. Once on the palette, the paint is diluted by adding water with the brush: the more water, the more transparent the resulting colour.

Diluting hard watercoloursAll that is required to extract the

All that is required to extract the colour from solid paint is to wet the brush and rub it gently on the paint. The paint softens under water and is absorbed by the brush. Rubbing the brush against the palette removes any excessive paint.

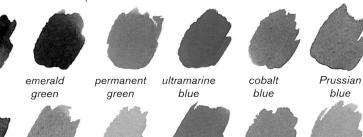

permanent

red

lemon

yellow

cadmium

red

orange

To mix solid colours, you must first wet them with a few drops of water and rub them with the brush to soften the paint. Once the brush has absorbed paint, transfer the absorbed paint to a small bowl. Add water and mix until the colours are properly blended.

Test the colour with a brushstroke on a piece of paper and add water or paint as necessary. Once the desired colour has been obtained, make sure to prepare the quantity that will be needed to cover the area to be painted.

Basic principles of painting with WASHES

Washes are the best way to start painting with watercolours. Working with a single colour will help in understanding how the dilution of the paint affects the intensity of tone. In this way, you will learn how to achieve the desired tone.

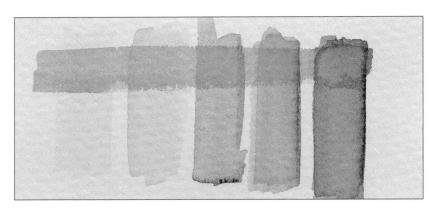

Dark colours are best for washes because they create greater contrast.

Washes

Washes rely on a relatively simple technique, consisting of placing colour on the wet brush and applying it to the paper. Water is then used to spread the paint and make it less intense. Generally, a wash consists of either one or two colours. Shapes are given form by incorporating white areas of the paper and, in part, through the tonal range of a colour.

The more water used, the lighter the colour. Notice how the superimposed horizontal stroke intensifies the tones underneath.

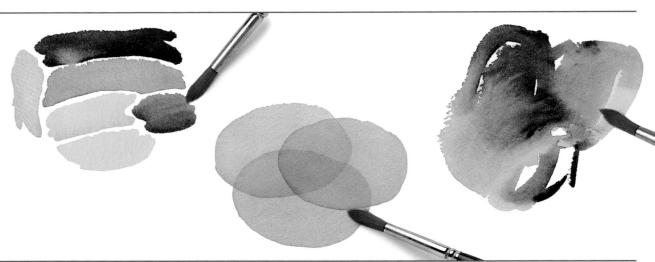

There are three basic ways of painting with monochrome washes: with uniform tones, with dissimilar tones, and with dissimilar tones separated by white spaces so that the colours do not mix.

Another commonly used technique is to build up colour in layers. Here, you can see how three transparent washes create darker areas by superimposing colours. An additional approach is to paint on wet paper. The colour values in the subject are recreated with one brushstroke that mixes the tones in a single wash. The result is an interesting gradation of tone.

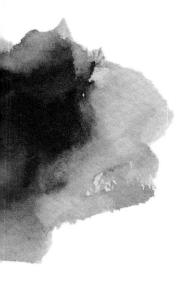

Tip

When working with washes, an incorrect assessment of tones when painting a subject can lead to an excessively dark area in the painting, making it necessary to darken the rest of the composition to maintain the right tonal relationship.

Painting with a single colour

Before beginning to paint with many colours, the novice should learn the rudiments of monochrome washes. Having mastered this, more complex colour techniques will be easier to learn. Even without experience in drawing, a little reflection makes it clear that working with washes is somewhat similar to drawing. The gradations of colour are much like certain effects that can be obtained in monochrome and blurred drawing. Thus, a wide variety of tones can be achieved without resorting to multiple colours.

More water, less colour

The quantity of water added to the paint on the palette controls the brightness of the effect created once the paint is applied to the paper. More water makes the paint more transparent; less water makes it more opaque and intense. Because the degree to which the white of the paper shines through the paint depends on its transparency or opacity, white paint is unnecessary in watercolour painting: the white tone is provided by the whiteness of the paper.

The initial washes should be with very light colours to avoid ending up with overly dark shadow areas.

Spreading a colour over the surface of the paper

First, place a spot of very intense colour on the paper. Then rinse the brush in a bowl or glass, press it dry, and spread the colour over the paper with the wet brush, allowing the water to flow and create a gradation of colour. The more the colour spreads, the lighter the tones will be.

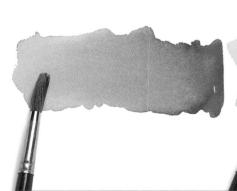

To spread the colour of a wash and obtain a gradation of tones, a first brushstroke of intense colour is followed by a wetter stroke, which, as the brush moves across the paper, adds water.

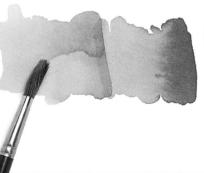

Gradations of tone are obtained by a single application of paint and a single pass with a watery brush. If done by stages, the wash becomes fragmented, with discontinuities of tone.

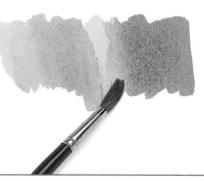

To deliberately cut a white swath across a gradation or to create highlights, a dry brush can be used on the wash while it is still wet.

Flat WASHES and WASHES with gradations

Watercolour mastery depends to a great extent on the artist's ability to control the application of washes, making them uniform or creating gradations of tone, as the particular situation requires.

Achieving uniform washes

A flat wash is one where the artist produces a single tone, so that what is seen is an even layer of paint without variations in tone or traces of the brush. When a wash is applied to dry paper, the painted area tends to be even and intense because, for the most part, the pigment does not spread. The result is a uniform colour and well-defined edges.

Using proper amounts

Flat washes are applied with a thick round brush or a wide brush — in other words, with a brush that can hold large quantities of paint and water.

It is important to prepare in a small bowl the amount of colour needed for the area to be painted, so that you do not run out of paint while working. In this way, you avoid interruptions or missing the precise tone desired.

Washes with gradations

In these washes, the colour is made to vary by a subtle gradation from a dark tone, generally at the top of the paper, toward a lighter, less intense one. The paint is applied in the same way as in a flat wash, except that the brush has more water and less pigment with each succeeding brushstroke. The key is to have the brush sufficiently saturated with paint so that the excess paint flows easily down the paper to meld into the next brushstroke.

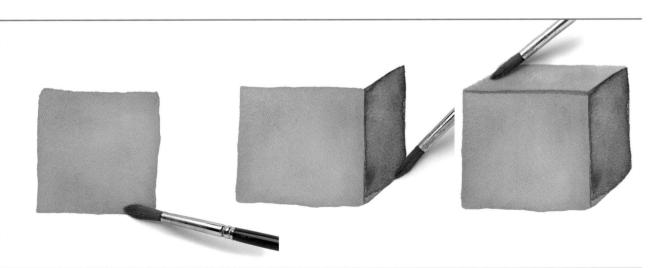

It is helpful to learn how to achieve flat, even washes that show no trace of the brush. Here we begin by painting a square area with a bit of red paint. After allowing the red area to dry, an even brown wash is added. Note that the first wash must be completely dry before applying the second.

The last step is to paint the cube with a uniform blue wash. The fact that each wash is superimposed on the preceding ones creates a slightly darker line that helps define the different planes of colour.

To create a gradation, paint an intense strip of colour on the upper part of the paper.

As water is added, the brush loses pigment so that the tone becomes lighter.

The paint is spread down the paper with horizontal strokes. Water is added with each new horizontal brushstroke.

Gentle gradations

To obtain a subtle gradation, it helps to wet the paper beforehand. The washes then spread more rapidly and in a less controlled manner, which can create astonishing effects. Learn to dilute the paint until just the right consistency is achieved. You will need to add more colour than seems necessary to cover an area, because some of the pigment is absorbed by the wet paper.

Blurred colours

Very pale colours in watercolour painting are simply the result of highly diluted paint. Any colour of paint can acquire this look by the addition of the proper amount of water. Such dilutions can help prevent excessive darkening or overly intense colour when multiple layers of paint are being used.

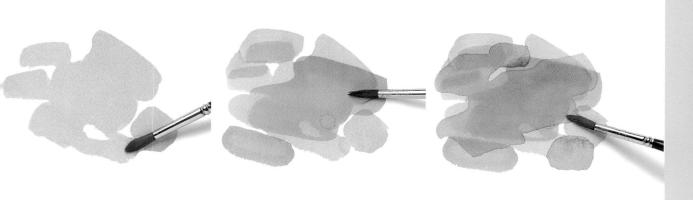

Watercolour artists use pale or watery colours to work in multiple layers. Here, an even, yellow area is painted on the paper.

When this yellow base layer is dry, apply a transparent wash of blue paint over it. Where the two overlap, areas of green are created.

Next comes a layer of carmine. Where the three washes overlap, the effect is brown; where the carmine overlaps only with the blue or yellow, violet and red-orange areas appear.

Watercolours can be mixed for optical effects by superimposing fine layers of transparent washes. To achieve the maximum effect, you should be familiar with the transparency

and solubility of the different pigments.

Multiple colours can be combined on paper to create a range of multiple mixtures. Juxtaposing different colours creates a variety of mixes that yield an intermediate hue.

Mixing on the palette

To begin exploring the possibilities of colour, place the colours on the palette. Next, prepare a wash of one colour in a container and a wash of another in a second. Mixing a small amount of these two washes in a third container will produce the first mix. By varying the proportions of the two washes in the mixture, you can achieve a variety of results.

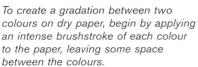

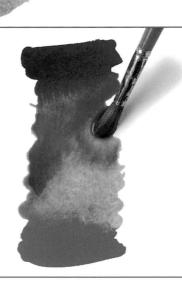

After cleaning the brush and dipping it in clean water, wet the area between the two colours, causing them to flow together.

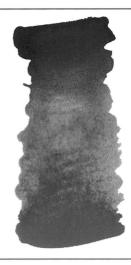

Finally, use a series of horizontal brushstrokes to meld the two colours together. The illustration shows the effect produced.

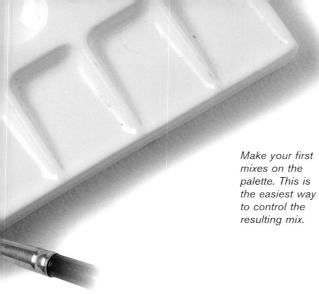

Tip

Though variegated washes like this are somewhat unpredictable and may create unintended effects, they can be used to create textures.

Mixes on paper

One way to ensure that only the necessary amount of colour is mixed is to apply each colour separately, mixing them on the paper. If you are painting quickly and know how the colours will react in the mix, this technique can yield good results, saving time and giving the colours a spontaneous appearance. If you are less confident of the result, you can test the mixture on a separate piece of paper before using it in the painting.

Two-colour gradations

To create a gradation of two different colours that can combine smoothly, you must first create a gradation of the lighter colour on wet paper. Then immediately apply the gradation of the darker colour until the two colours merge in the area where the tones are least intense. In this intermediate area you will see a gentle gradation where the two colours mix.

Variegated mixes

Mixtures created by painting with a wet brush on wet paper create a variegated effect. When the paper is made wet before the first colour is applied, the final effect obtained is more intense than that achieved by applying the first colour on dry paper and then overlaying a second colour wash.

If two colours are mixed on a wet surface, the brushstrokes of the second colour expand in all directions and mix partially with the first colour.

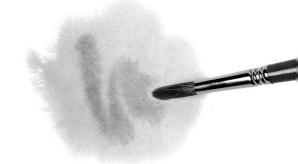

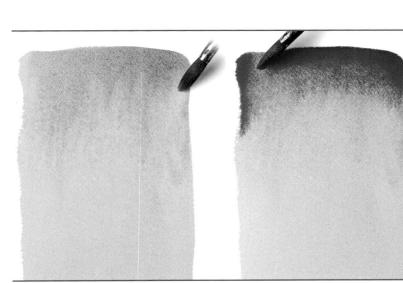

Creating a two-colour gradation on wet paper is easier than on a dry surface. First paint the designated area with the lighter of the two colours.

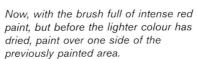

Finally, tilt the paper slightly and let gravity do the rest. The red runs down, spreading a veil of colour that becomes lighter as it flows down on the paper.

GRADATIONS ON A WET SURFACE

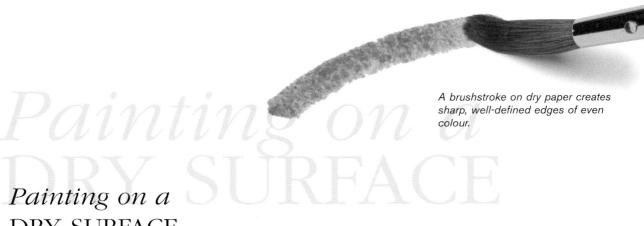

DRY SURFACE

Dry watercolour painting is a classic technique of painting on dry paper. Here the tones and colours are applied in a series of layers, allowing each to dry before the next is applied. A dry brush provides one of the most expressive techniques in this type of painting.

Dry paper

Dry paper easily absorbs paint, enabling colours to quickly become fixed and dry. The colours are intense and edges are clearly defined. Gradations are therefore more difficult to achieve on dry paper and discontinuities in colour may occur. On the other hand, the results of painting on a dry surface are easier to control than when using a wet technique.

Dry-brush technique

Dry brushing consists of applying paint with little water on the brush. The bristles of the brush are drawn over dry paper while applying a small amount of friction. The paint thus adheres to the grain of the paper, creating a dry, sandy sensation. Dry-brush techniques can be used on white paper or on paper previously treated with a wash. It is important that the brush holds the precise amount of paint needed. Otherwise, the background is covered by too much paint and the desired effect is lost.

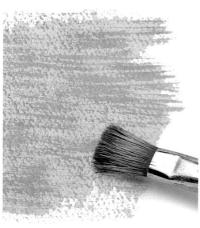

To work with a dry brush, the paper must have a special texture or grain. which absorbs the paint and yields a luminous effect.

With a somewhat wetter brush, you can achieve short, highly transparent, streaked brushstrokes. These brushstrokes are important when attempting to achieve an expressionistic effect.

Brushstrokes on a dry surface do not have to be uniform. You can even combine two colours on the brush, creating a stroke that contains its own gradation.

Dry-brush technique requires judging the precise amount of paint needed on the brush. The paint should be creamy, not watery.

Layer effects

rough, grainy texture

This type of work requires

Layers can also be created with dry brushstrokes. As with

transparent washes, two tones or colours can be blended this way. The brush works over an area that already contains colour, creating a

superimposed on the first layer of colour. The result is a visual effect that recalls impressionist painting.

patience, because each layer must dry before the next is painted.

Using water to soften edges

There are two ways to soften the edge of an area of colour. One is to use a dry brush; the other is to treat the edge with a little water. When a shape is too sharply defined, you can blur it by adding clean water with a soft brush at its edges. Simply wait a few seconds for the paint to soften, and watch the colour spread slightly. Then allow it to dry.

Once the paint is moistened, the edge is softened delicately.

Another commonly used technique is to apply textured dry layers over washes. Applying blue brushstrokes over a yellow wash produces green areas.

This technique can be used in combination with a wet approach by applying the drier paint over a wash, thus producing a striated stroke.

The edges of a wash can also be softened. The brush should be wet but not soaked with the colour of the wash. Then the edge of the area is stroked with the hairs of the brush until the edge blurs.

PAINTING SKIES

As you might imagine, gradated washes have a variety of applications. Their main use is as background for landscapes to suggest the sky. There are various ways of creating a gradation to represent the sky: dry, wet, with edges and with clouds. Here, each way is examined.

The first step in painting a gradation for a sky with a single colour is to apply ample colour to the upper part of the composition.

With the brush well wetted, move down the paper, creating a colour gradation with horizontal brushstrokes.

Once the paper is covered, remove the extra water from the bottom of the paper with a paper towel. This is the result.

To combine two sky colours using a wet technique, first moisten the paper. Then apply the first colour with brushstrokes at the bottom of the paper.

Apply a second colour at the top of the paper and create a gradation as in the previous example, until the two colours meet.

Washes in gradations should be done quickly and with a sure hand. You should avoid moving back with the brush over areas already covered, because doing so can alter the tone. The result is a two-colour gradated sky.

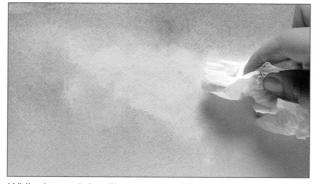

While the wash is still wet, some of the moisture can be absorbed with a crumpled paper towel. The result is a sky with great, irregularly shaped cumulus clouds.

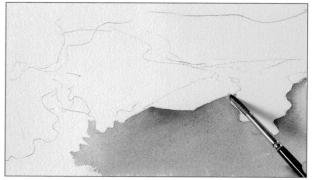

When a horizon is complex and jagged, the sky must be painted in a different way. If the surface on which you are painting is tilted, the paint from the upper part of the paper may flow down and dirty the lower part. In this case, simply place your easel or board upside down and use a smaller, round brush to carefully work the edge of the horizon.

STARTING WITH THE PLACEMENT OF SHADOWS

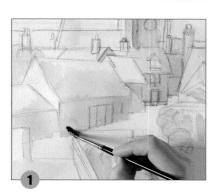

Many artists begin by painting the shadows of their subject with flat blue washes or with a layer composed of various tones or colours. This approach helps to frame the subject at the outset, creating a solid structure for the painting. Moreover, by placing the shadows at the start, the problem of shifting light which can plague an artist working outdoors is eliminated.

- 1. With uniform blue washes, outline the position of shadows in the drawing.
- 2. When the blue washes have dried, apply an even ochre wash on top.
- 3. With the shadows and the ochre layer in place, the painting is half finished. Now all that is needed is to add a few more colours.

Placing the shadows

To place the shadows, begin with a pencil sketch of the subject. Then take a diluted mix of bluish wash and paint only the shadow areas. Bear in mind what was learned about working with a single colour.

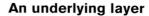

The underlying painting serves as a tonal base for the final work. This is, in effect, a sketch of the final work done in one or more colours. This stage is similar to the shadow placing but uses greater variations in tone and colour, so that there is a greater sense of volume. Once this has been completed, apply an ochre layer, as in the preceding exercise.

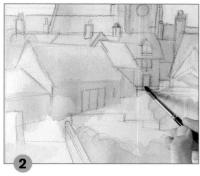

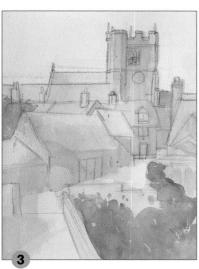

- 1. The strategy of an initial compositional layer on top of a pencil sketch calls for painting the shadow areas first and uses variations of tone and contrast that provide the basis for the tonal balance of the final work, thus preventing misjudgments or errors that cannot be corrected.
- 2. As in shadow technique, once the process is completed, an ochre layer is applied. Comparing this technique with that of the previous exercise, you can see the difference created by working at the start with a wider range of colour values.

WET TECHNIQUE I O U E

This is one of the most expressive techniques available to the watercolourist. When colours are applied on wet paper or on an area of still-moist paint they spread and create soft contours and misty shapes.

Controlling wetness

Wet technique means painting on wet paper. This allows the colours to expand in an uncontrolled fashion, merging, saturating and expanding in a variety of ways. Controlling the wetness of the paper makes it possible nonetheless to work with great precision, because the wetness of the paper determines the extent to which a colour will spread.

Unpredictable effects

On a wet surface the brush moves easily, the paint runs and the pigment spreads freely in all directions. This means that the result is somewhat unpredictable, creating a blurred, misty effect. Shapes are not entirely distinct, because the colours blend gradually into each other.

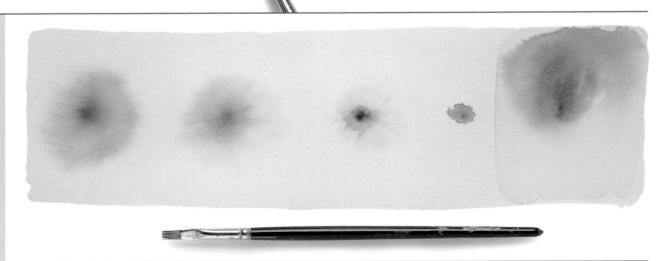

Note what happens when paint is applied to moistened paper at different time intervals. The first point of colour at the left was made on very wet paper with a transparent wash.

One minute later, colour is applied a second time. After two minutes this is repeated. After four minutes, you can see that when applied, the colour spreads only slightly. The final sample

was made a minute and a half after wetting the paper with various colours and tilting the paper slightly.

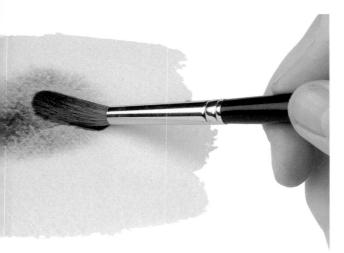

Tip

It is easy to correct errors in wet technique. Washes that are not of the desired colour can be rubbed out with a moistened sponge.

When painting on wet paper, the paint spreads uncontrollably.

This peach has been painted using a mixed-colour technique on a wet surface. Red brushstrokes were added to the yellow wash, with a resulting irregular mix of colours.

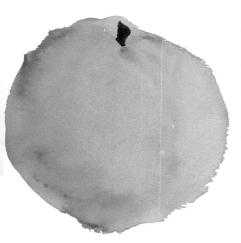

Degree of dampness

The dampness of the paper during the painting process plays a major role in the final result. The paper may be moistened with a sponge, a brush or under the tap. The method chosen will depend on how wet you wish the paper to be. Remember that the spread of the pigment is proportional to the amount of water on the paper. The wetter the paper is when it receives the paint, the larger the area of colour expansion will be and the more diffuse its edges.

Fluidity of the paint

Though painting on wet paper can create wonderfully spontaneous effects, practice and experience are required to know how wet the paper should be and what amount of water is needed to keep the fluidity and spread of the colours under control. You must paint with very intense colours - considerably more intense than what you desire the final effect to be. Bear in mind that the colour will appear darker when wet, then become lighter as it dries. Thus, when painting on wet paper you should avoid diluting the paint too much, so that the painting does not end up appearing pale and lacking in contrast.

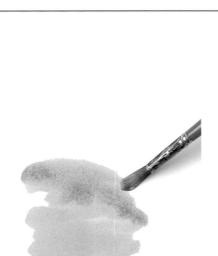

Here, you see how the colours react if a spectrum of colours is painted on wet paper. First, yellow and red are applied. Already, they spread.

With each new brushstroke, the wash comes to life more, blending neighbouring colours into blurry and unexpected borders.

You can either wait a few minutes for the colours to finish spreading or change a few areas by adding more water to start the washes flowing again.

THE IMPORTANCE OF THE WHITE PAPER

Because of its transparency, white paint does not produce a pure effect in watercolour work and is therefore not used. Instead, the paper serves where needed as the source of white. The simplest way to create touches of white light in a watercolour painting is to apply colour around the area of light, or to shield it with masking liquid, which keeps the whiteness of the paper intact.

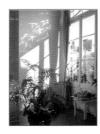

To preserve white space, first study the subject and decide where the paper should be left blank. In this case, it is clear that the windowpanes and light areas on the back wall must be kept white.

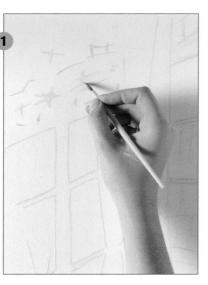

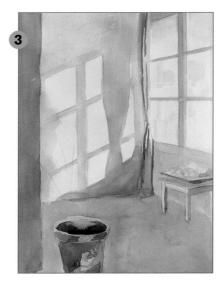

- 1. Because the light reflections on the upper part of the wall cover such a small area, masking liquid is a good way to create them. Before applying any wash, brush on masking liquid where these reflections appear. Then wait for it to dry before applying colours.
- 2. When painting around a shape that is to be highlighted in white, allow the paint to dry and form defined borders. Apply colour, avoiding any overlap into areas that are to remain white.
- 3. For more intense whites, intensify the tone of the colour around the protected areas. The whiteness will stand out more by contrast.

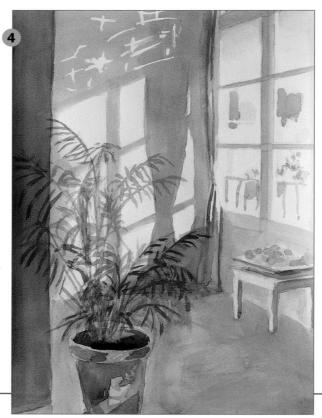

4. Once the painting is completed and is entirely dry, rub the masking liquid with a finger to remove it. You can see that the paper has remained white.

PAINTING by STAGES

When mixing colours directly on paper it is wise to paint by stages and, one by one, complete each area of the painting. The colours painted in each area will be the final colours and will not be modified by subsequent layers or washes. This approach, which requires mixing colours judiciously, is highly favoured by amateur watercolourists. The following will provide a better understanding of the technique involved.

1. First, make a line drawing of the subject. Then treat the background with a very transparent wash in which ochre and Payne's grey are mixed unevenly. For the dark part of the lower area, burnt umber and Payne's grey are used.

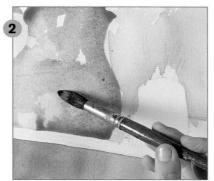

2. Mixing burnt umber over wet ochre, paint the ceramic jar so that the right side, on which less light falls, is more intense in colour.

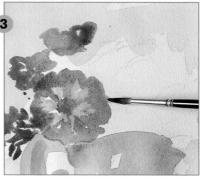

3. Next, we use a round brush to paint the flowers one by one, mixing the colours on the paper rather than on the palette. Adding a touch of carmine to a blue can produce a stunning range of violets.

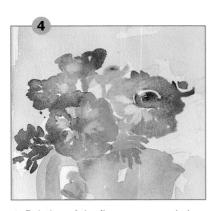

4. Painting of the flowers proceeds by stages, mixing the colours directly on the paper. The light tones of the petals are obtained by dabbing at the still-wet colour with a piece of absorbent paper.

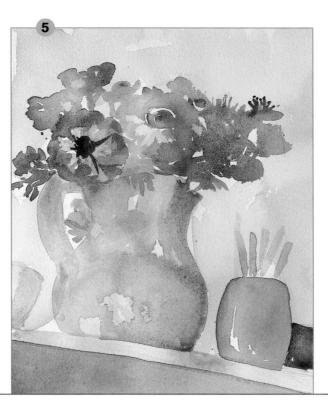

5. A few more strokes complete the flower arrangement. In this last area, violet, carmine and green have been combined, allowing the colours to mix in a haphazard way.

PRACTICAL

EXERCISES PRACTICAL EXERCISES

his section describes the classic method of watercolour painting, which any beginner can learn through practice by following certain simple guidelines. Elements of chance and risk can make watercolour painting a frustrating medium at times, but at others, a rich and stimulating one. The exercises provided here will help expand the reader's mastery of the medium.

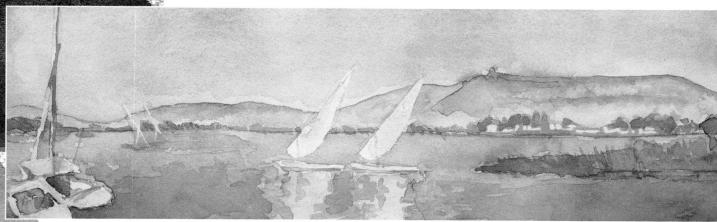

MONOCHROME

Interior with MONOCHROME WASH

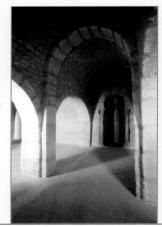

Washes make it possible to derive different tones from only one colour by varying the amount of water added to the paint. Here, an interior will be painted using layers that gradually intensify the tones. The exercise begins with lighter washes of grey and ends with the darker ones. This will not be difficult if you follow the instructions.

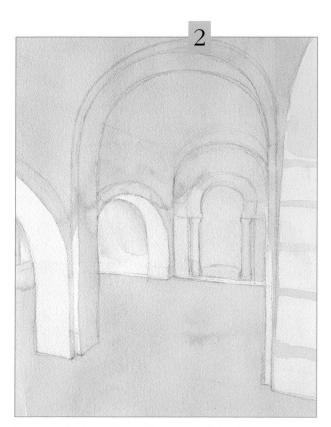

The areas in the subject with the most light should be left white when applying the first wash, which should be a very dilute mixture. These areas need not be painted and can be left untouched by brushstrokes.

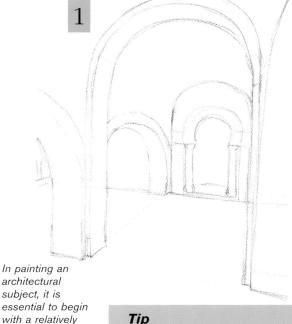

Tip

accurate sketch. You may wish to

first draw a few

vanishing point,

to help represent

the depth of the

lines to the

interior

perspective.

It is not advisable to start a painting with dark tones. With watercolours you cannot superimpose a light tone on a darker one. If some areas are made too dark, you will be compelled to darken the entire painting to retain the relative balance.

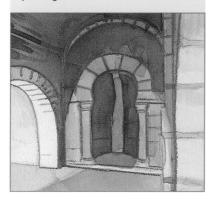

Strengthen the effect of the initial washes by laying a medium-tone wash over them. Finish painting the vault by tracing the shape of the arches with the wash. With the tip of the brush, suggest the blocks of stone in the arches and columns, always maintaining the same overall tone.

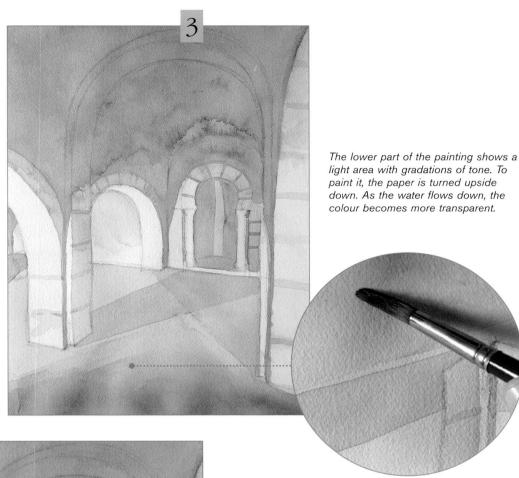

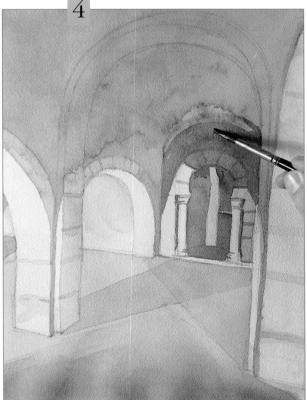

Again, wait for the previous layer of colour to dry before attempting to darken the tone of the walls that are in the shade. It is important to respect the structure of the architecture at all times, since, after all, it is the main attraction.

Tip

If you find yourself "playing it safe" by working only in intermediate tones, force yourself to take risks; otherwise you can end up with a painting that is flat and uninteresting, one that lacks expressiveness and focus.

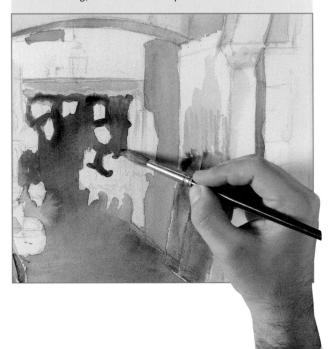

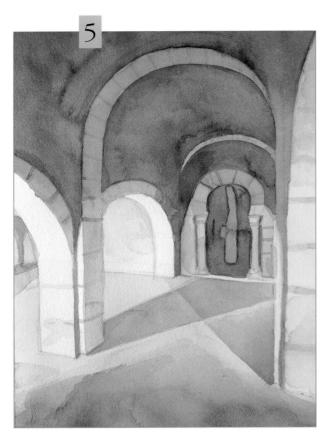

Cover the vault of the ceiling completely with another darker wash, but keep the stone arches lighter to make them stand out by contrast. As the tone of the paint increases, it will be necessary to intensify the shadows projected on the floor.

Tip

While applying the final washes, you can go over the initial sketch with a graphite pencil to give shapes more definition and strengthen their outlines.

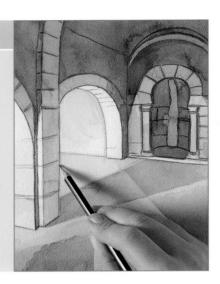

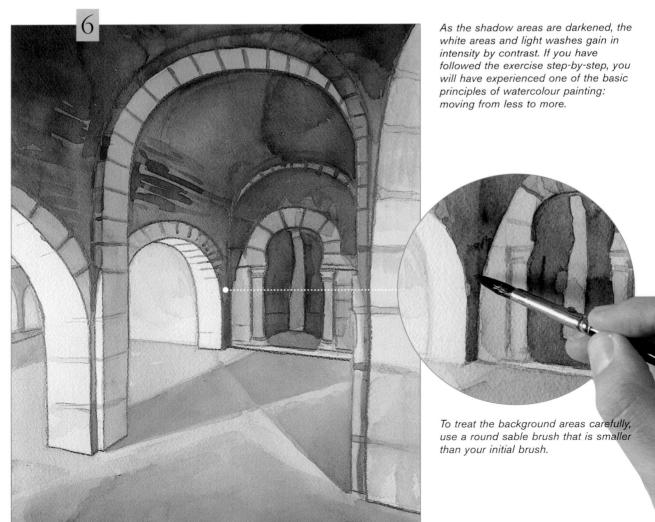

MASTERING WASHES

When coloured washes have been mixed on the palette, it is important to become accustomed to trying them out on a separate piece of paper. This will ensure that the desired tone is achieved. Here are some exercises in monochrome washes.

The first element to be mastered in creating a wash is control over the water added. The best way of doing this is by thinking in terms of a simple scale of tones, bearing in mind that the more water you add to the paint, the softer and more transparent the wash will be.

In working with monochrome washes, the effect of superimposing is critical. You can practise your skill as indicated in this exercise, which consists of progressively darkening a colour by superimposing successive layers on a dry surface.

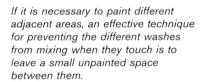

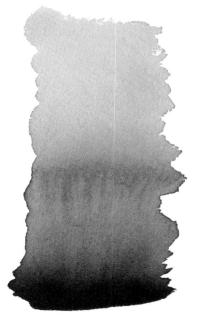

It is also important to learn how to make the wash flow. Once a colour has been applied, a gentle gradation can be created by simply adding water and working the brush over the area.

trace them with the brush in a monochrome wash with gradations. This is a simple but effective exercise.

PAINTING A LANDSCAPE URS with two COLOURS

Working with a two-colour wash is a good way of learning to balance tones and play with contrasts of tone and colour. This is an important step before moving into the world of multiple colours, which is a more complex challenge. For this exercise, choose two colours, a blue from the cool end of the spectrum and a yellow ochre from the warm end.

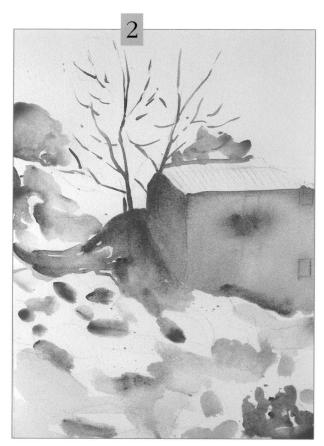

Working with only a blue wash, begin painting the shadows, as explained earlier. These initial washes are not final, serving rather as a base upon which to add warm tones later.

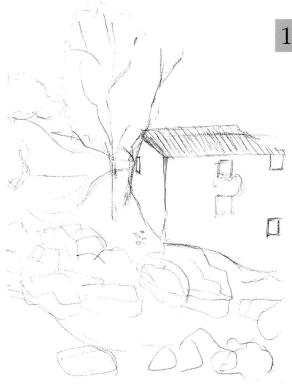

With increasing experience in handling watercolours, you will come to appreciate the fundamental role of drawing, which provides the contours within which the paint is applied. Here, use a graphite pencil to sketch the main lines.

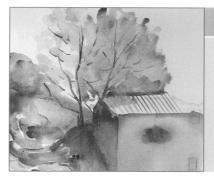

Tip

If the landscape you are going to paint has little depth, it is best to leave the sky unpainted.

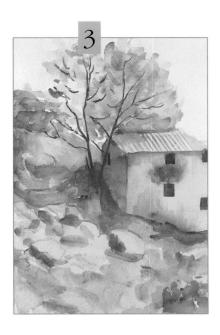

Continue working in one colour, sketching in more accurately the tree's branches and the windows of the house. Then apply new washes to soften the whiteness of the paper and ready the background on which to lay more colour.

Tip

A common method of rendering foliage is to mix the colours directly on wet paper.

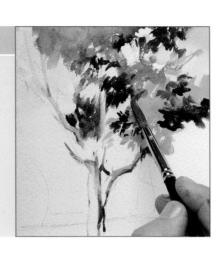

Apply a patina of colour over your monochrome base. Notice that the transparency of the ochre wash allows the previous blue areas to show through, though they are darkened and made somewhat grey by the superimposition of the ochre.

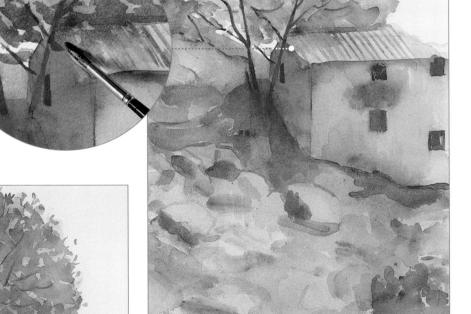

To paint the foliage of the tree, use a saturated ochre in the upper section and add a touch of blue to the lower area. Use a fine round brush, mixing some of the colour directly on the paper.

The combination of the two colours in the painting produces a contrast of warm and cool colours, revealing a mix of the two and resulting in a rich range of greys. Notice that a grey wash is applied to cover the lower part of the tree, house and some of the curved shapes of the rocks.

To learn how to create greater contrasts with two colours, repeat this exercise with blue and orange. Being complementary colours, they contrast more and provide more luminosity than the colours used here.

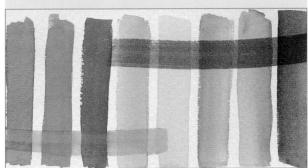

Now cover the lawn area with a more intense ochre wash to provide a warm note in the sunny areas. As shown here, leave the rocks untouched, so that they retain their predominantly blue colour.

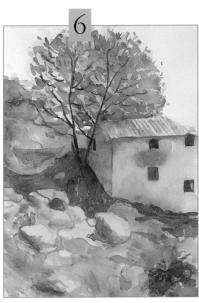

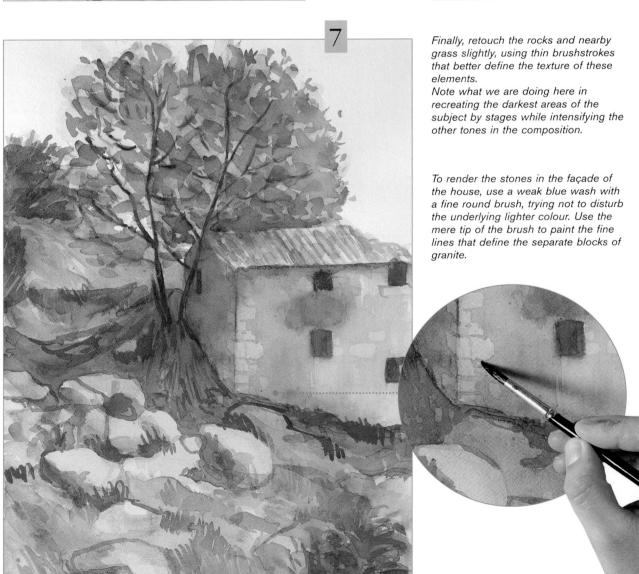

MIXING two COLOURS

Painting with only two colours is an interesting exercise that makes use of the contrast between them and of the nuances that result from mixing them. Before trying your hand at the previous exercise, you may want to do the following exercises, which will help you gain experience with colour mixtures.

First, dilute the two colours gradually to gauge their amount of pigment or transparency.

Mixing the two colours wet is one way to find out which is dominant. In this case, the blue is more powerful and tends to overpower the ochre wash.

The blue will therefore be better as an underlying colour. The ochre, being more transparent, will work well as an overlay.

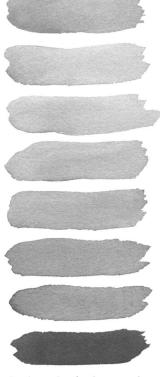

A simple scale of values can be created. Note the range that the two colours are capable of producing by mixing them in varying proportions.

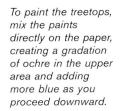

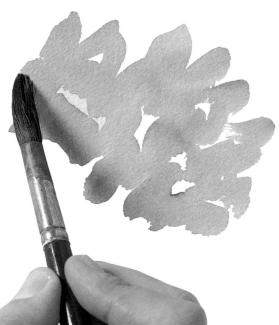

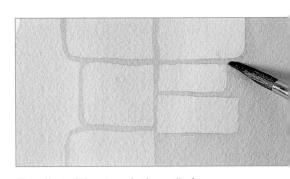

The effect of the stone in the wall of the house is obtained by applying an ochre wash over a bluish background, leaving the space occupied by the stones as background colour and painting the rest of the wall.

PRIMARY

STILL LIFE with SPRIMARY colours

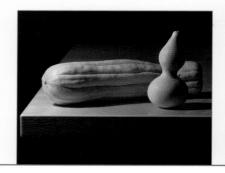

In this exercise, only the three primary colours – cerulean blue, carmine and yellow – will be used. The variety of tones and nuances in the painting will be created by mixing these three colours in different proportions. A painter must be intimately familiar with the three primary colours, because it is through these that all other colours can be created, according to need.

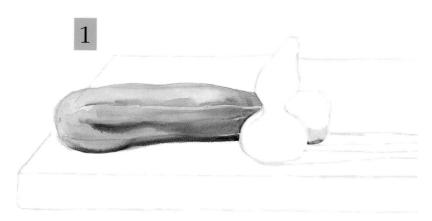

First make a line drawing of the subject without spending time on details. Start by painting the long squash yellow as a base colour. Paint the shadows with a wet mixture of carmine and blue.

Tip

Here are some entertaining exercises that will help you explore the process of mixing the primary colours.

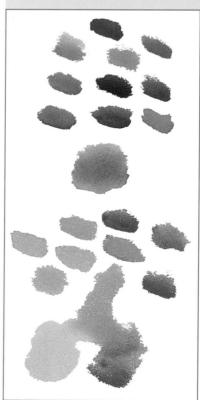

The painting is done one area at a time, mixing the colours with a fine round brush and applying it directly to the paper.

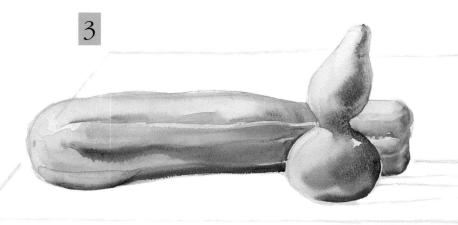

In painting the bottleshaped squash, make the base a paler yellow. Then, while the paper is still moist, apply a violet mix made from carmine and blue to the shadow area. The colour will gently spread on the wet paper, producing soft tonal transitions.

Tip

When painting with three colours, place them close to one another on the palette and prepare the mixes in the spaces between them.

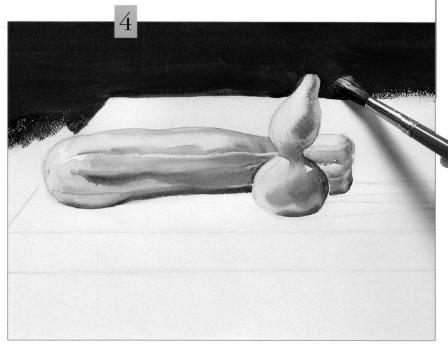

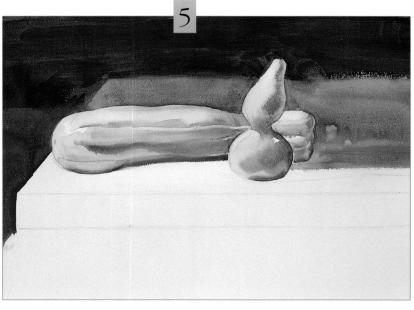

Now cover the background with a darker, more intense colour, obtained by combining the three primary colours in equal proportions. Use a mediumsized round brush to cover the background and outline the edge of the table.

An equal mix of carmine and yellow, with a bit of blue, produces the brown for colouring the table. Paint the table while the background is still wet, to give the edges an out-of-focus look.

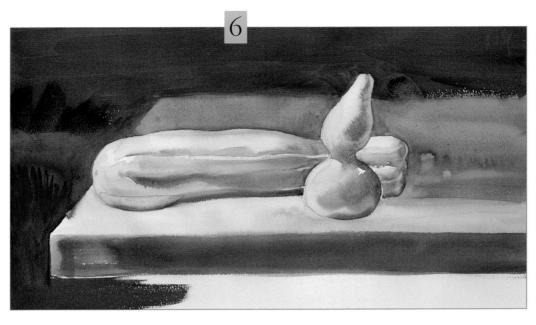

To paint the brighter part of the table, use a very watery wash of the same brown used before on the table. Now paint the edge with a new, intense brown wash.

All that remains is to paint the dark background at the lower side of the table; then use the same colour to render the shadows projected by the two squashes. The mixes you are using provide a good introduction to the challenge of mixing colours in watercolour painting.

Tip

Mixing the three primary colours in equal amounts produces a very dark, almost black colour.

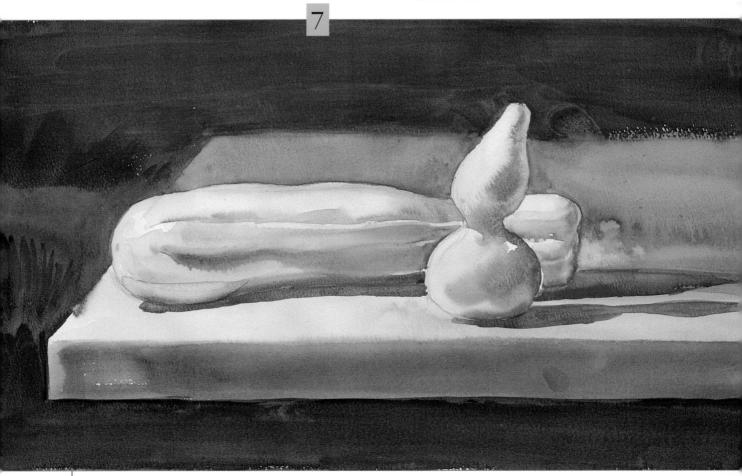

MIXTURES using WET TECHNIQUE

Colours can be mixed directly on paper. One way of producing spontaneous effects is to paint one area at a time on wet paper. Begin by applying a colour directly to the paper. Then, before it dries, apply other colours on top to obtain gentle gradations of tone. You will become better acquainted with this technique by studying further the effect you achieved previously in painting the squash.

First apply the base colour, in this case an intense cadmium yellow.

Over the wet wash apply a second colour, a blue with a touch of carmine.

Almost immediately apply a third brushstroke of carmine to the left of the blue, so that the two colours merge randomly.

With the brush soaked with water, finish mixing the carmine and blue, which yields on paper a new grey area. With the same soaked brush, wet the paper to the right of the painted area.

Now trace a line of carmine mixed with some blue on the wet paper.

The brushstroke full of carmine will spread quickly over the wet surface of the paper. Experiments like this will help you

Experiments like this will help you understand how colours react in this type of technique.

HAT

Rural scene with FLAT COLOURS

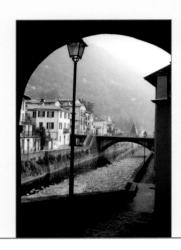

We will now paint a rural scene with flat tones, which will help you practise with the type of uniform washes described in the first part of the book. To provide a special effect to this exercise, we will use weaker, less luminous greyish mixtures.

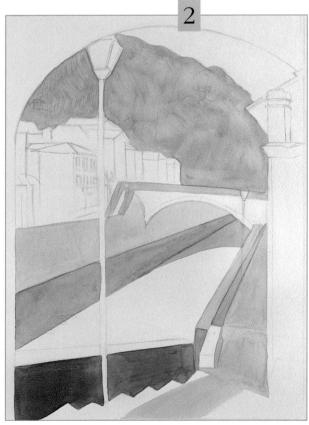

Create very transparent washes of Payne's grey for the sky and river, with yellow ochre and a bit of grey for the water edges and ivory black for the shadow area at the bottom.

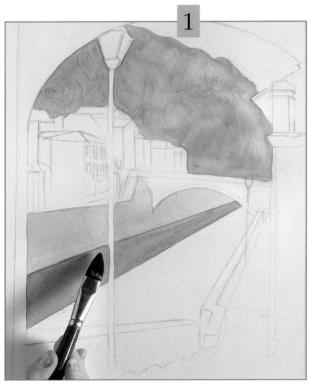

First, do a rough sketch of the details of the subject, including its perspective. Then work on one area at a time, applying an initial series of monochrome washes that fill in the contours of the drawing.

Tip

The washes in this exercise should be consistent with the real subject, bearing in mind that watercolours lose intensity when they dry. It is helpful to test the colours to be used on a separate piece of paper before using them in the painting.

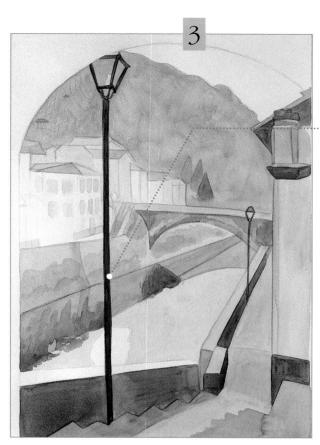

Cover with transparent reddish-ochre washes the façades of the houses. Touches of darker grey provide contrast and architectural detail.

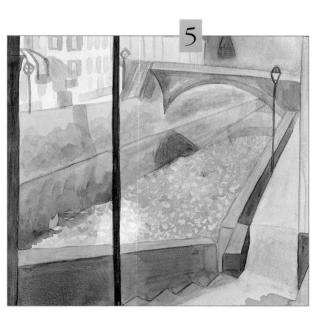

The surface of the water is suggested by a bluish-grey wash layer, taking care to leave small areas or spots untouched to create the effect of texture and movement.

Paint the backlit lamp in the foreground with a fine round brush. This brush can also be used to paint a second tone at the edge of the river.

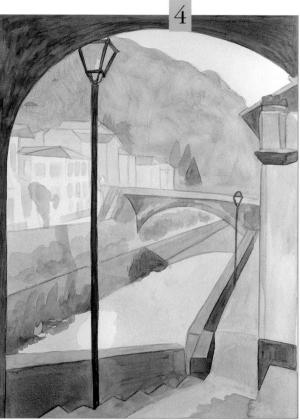

The same Payne's grey used to paint the architectural shadows now serves to colour the dark silhouette of the arch that frames the scene. To differentiate this wash from the preceding ones, add a touch of blue to the grey.

When attempting to create hybrid or slightly muddy colours, use a mixture of the colours on the palette. Another way is to simply not cleanse the brush in clean water.

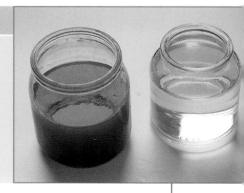

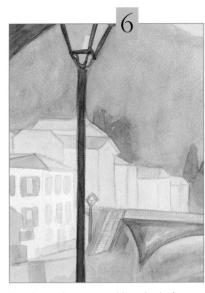

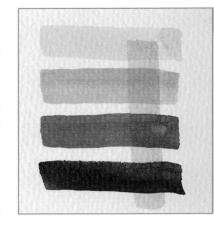

The greys in this exercise result from mixing the three primary colours in different proportions. Note that greys can be found in virtually any subject, outdoors or indoors, because they appear so often in painting shadows.

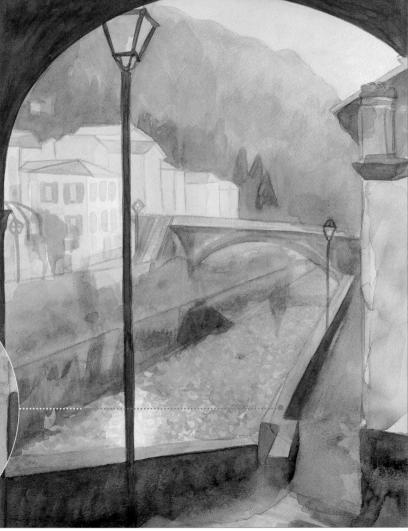

Now, darken the river and add some irregular green spots to the background vegetation, as well as some sienna on the foreground stairs. Apply each colour addition after the previous one has dried completely. This is essential if the tones in each area are to remain distinct.

INCORPORATING LINE TRACING in WATERCOLOURS

Normally we paint over a pencil sketch consisting simply of a few lines that serve to outline the area where colour is to be applied. These lines often remain in place when the painting is finished. However, this is not the only way of incorporating line tracings in watercolour painting. This can be accomplished with a range of techniques that yield their own distinct results, as will now be shown.

While the wash is wet, gently rub the surface of the paper with a pointed metal object until darker lines of the same colour as the wash appear.

A reed pen is a very useful tool. When used on a dry wash, the resulting line is clear and sharp.

If a reed pen is used on a wet wash, the line tracing widens and is less sharp, but the effect can be highly appealing.

A pen with a metal point creates a sharp, intense line on a dry surface (left) and a broken or wobbly line on wet paint (right).

A line made with the tip of a brush does not necessarily have to be of a single colour, but can include a gradation of different colours.

If one begins by drawing lines with a watercolour pencil, they remain visible even after a wash is applied over them. They will, however, lose sharpness and some of their original pigmentation, which becomes a part of the wash.

A striated stroke can be obtained with a fan-shaped brush. The effect is that of a series of parallel lines of differing thickness. This is effective in representing the texture of wood.

A sharp-pointed brush is useful for painting lines. When saturated with paint and water it produces an intense and flowing line.

When the brush is soaked with paint but without much water, the line is drier and more broken.

STILL LIFE with OUF DRY TECHNIQUE

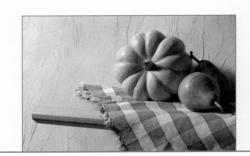

Here, we propose to paint a still life using a relatively dry brush. The wetness or dryness of the paint is, of course, a determining factor in controlling the gradations, textures and mixtures of colour. Expert alterations of the wet film of paint can create a speckled or sandy effect. For this exercise in dry painting, easy subjects have been selected.

It is relatively simple to draw objects that do not require absolute symmetry – a pear or squash, for instance – because all that is required is to indicate with a modicum of precision the sizes and shapes of the objects and the relation between them.

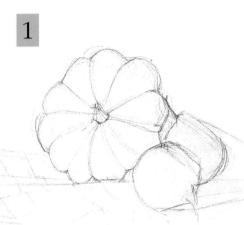

Tip

It is important to place the proper amount of paint on the brush. Otherwise, too much colour will spill on the paper and the effect of the work will be ruined.

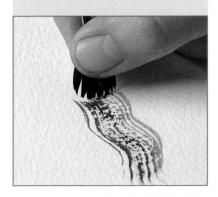

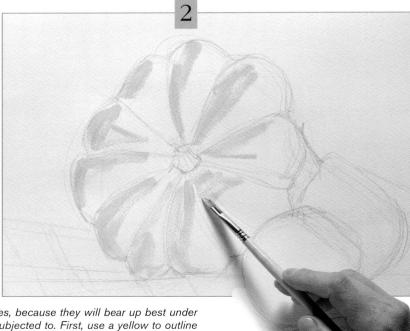

Begin with bristle brushes, because they will bear up best under the rubbing they will be subjected to. First, use a yellow to outline the brighter sections of the squash. We start painting with the light tones and move slowly toward the darker ones.

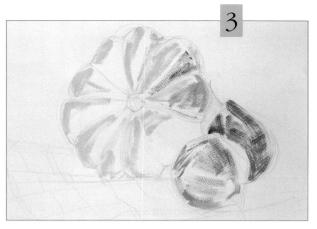

Next, add some green tones to the pears and squash. Use an almost-dry brush to prevent the paint from creating a defined tracing and to produce a rough texture.

Tip

This technique works best with solid paints. Use a damp, but not soaked, brush to paint.

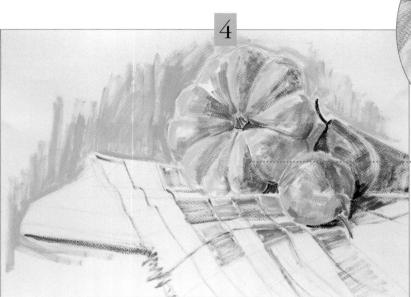

The brushstrokes must be quick and firm, because working at a slow pace will prevent us from achieving the grainy effect we want.

Use a greyish green to outline the edge of the tablecloth and a very pale ochre to cover the large background area with vertical brushstrokes. Choose a lighter green mixed with ochre for the shadows of the squash. In this first stage it is important to reproduce the tones and colours of the subject as closely as possible.

Now cover the white spaces in the composition – the table, for instance, which will be painted with ochre. Apply new colours on the fruit to better convey their volume through variations of light and dark tones on their surface.

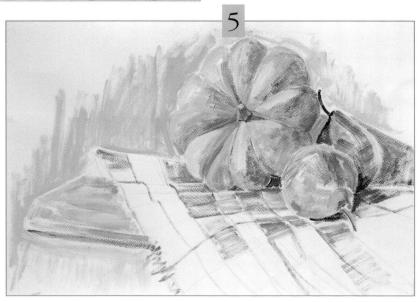

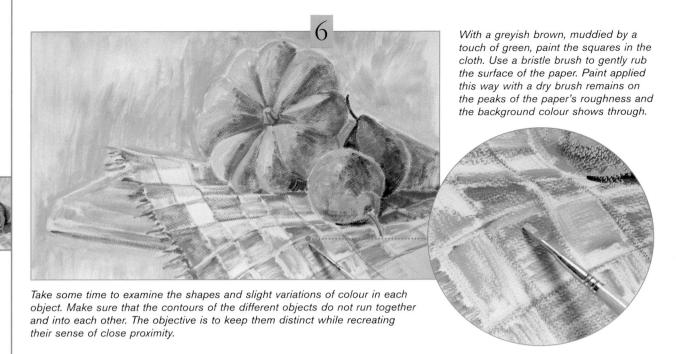

Finally, apply the darker colours – the greys and browns that give the fruit volume. These colours can be applied to the tablecloth to let the background breathe or they can be used on an area already painted in to create a veiled effect.

Tip

The grainy texture of the dry paint can now be enhanced by rubbing the painted surface with sandpaper. This makes the grain of the paper more visible as the peaks of the paper's rough texture are discoloured by the sandpaper while the colour in the depressions remains intact.

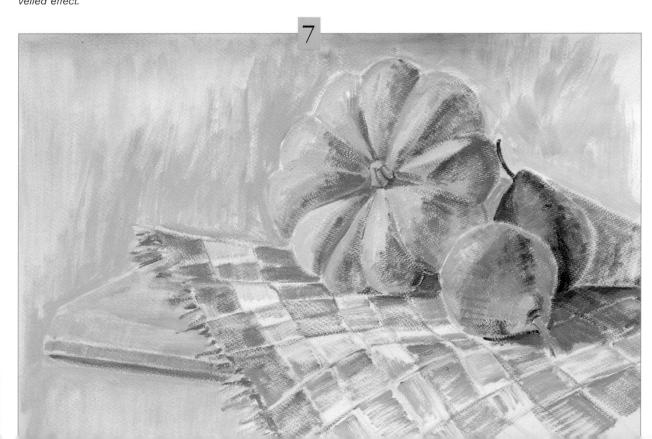

A BRIEF CATALOGUE OF TEXTURES AND EFFECTS

Many professional watercolourists use only paints, a few brushes and a container of water. However, a number of techniques or tricks can be great fun for the beginner and can open the door to a wealth of methods capable of imitating and suggesting textures.

Salt scattered over a wet wash creates an irregular, porous texture.

Placing the salt in one spot creates an irregular shape with a lighter halo surrounding it.

When a wash is almost dry, some of the colour can be removed by scraping the surface with a knife.

A nearly dry brush can create fascinating textures. The result is grainy, because the colour is deposited on the high points of the paper's texture.

By gently rubbing a brush with very thick paint over an already painted surface, paint can be deposited on only the high points of the paper's surface, leaving the background colour to show through.

Applying a few drops of clean water to a painted area that is nearly dry can make the particles of colour separate and accumulate at the edges of the area.

Varnish can be applied to selected areas before using the paints. Once the varnish is dry, the paper will repel paint in the varnished places, pushing the pigment to the edges of the area, where it creates a blurry effect.

Paint some lines with masking liquid. Apply a wash over it. When the paint is dry, rub off the masking liquid with a finger. The result is bare white strokes standing out in the midst of the painted area.

If we use a wax pencil to trace lines on grainy paper and then apply a wash, the traces remain visible because the wax repels the wash.

PAINTING

PAINTING TRANSPARENT OBJECTS: glass bottles

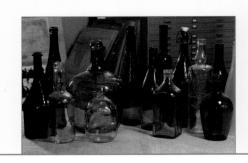

In this exercise, we will paint a group of glass bottles. The transparency of the glass is a major challenge. The glass allows light to pass through, making it possible to glimpse what is behind the glass. Complicating matters further, the glass may reflect nearby objects and display shiny spots where it reflects light.

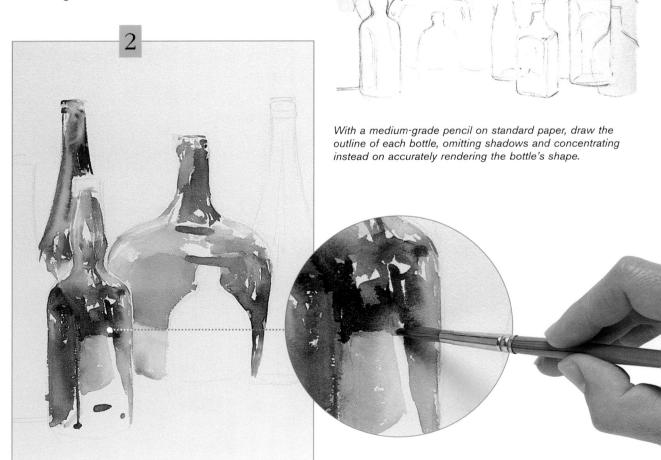

Start applying colour to the first group of bottles, using green washes unevenly mixed with ochre, sienna and violet. As work proceeds, avoid applying paint to the small areas where the paper's bare reflective surface will be needed to create shiny highlights on the bottles' surfaces.

Paint the bottle in related tonalities, outlining its shape and rendering the tone of the glass by mixing colours directly on the paper. In this way, the different colours will meld, forming gentle transitions.

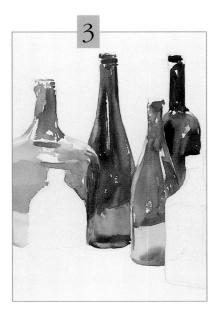

Paint the next group of three bottles with sienna, ochre, burnt umber and a touch of green for the mixes. Note that the final colour of the foreground bottle changes, based on the reflected colours of the nearby bottles and of those behind it.

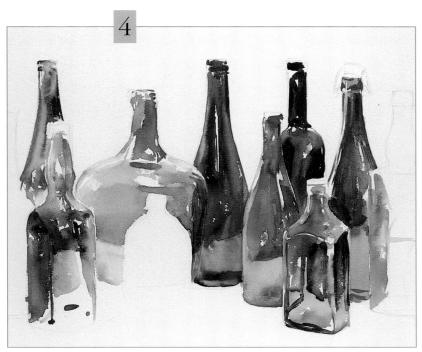

Use blue and lilac washes for the two bottles in the centre, Prussian blue on the neck of the tall bottle and violet on the lower part. The same violet with some added blue is used on the lower bottle in the foreground. Paint the central part of this bottle darker, since it reflects the colour of the bottle behind it.

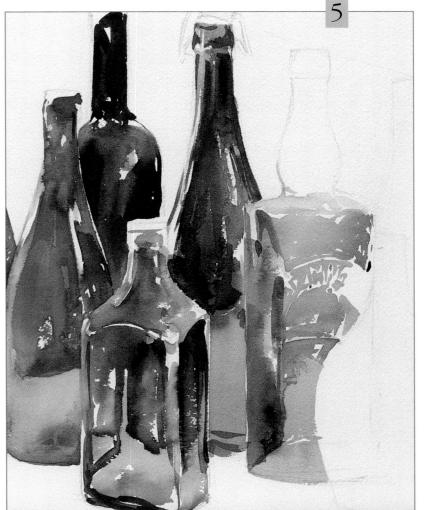

Coloured glass changes the colours of see-through objects behind it; it also projects its colour on its own shadow and on nearby objects.

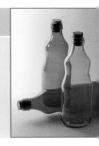

Use the same range of violets as before, adding a touch of orange, for the transparent bottle at the right, which must be painted with great care. It is essential to leave white traces for the graphic that is stamped into the glass. To paint the outline of the bottle at the left that is seen through the glass of the bottle in front of it, use Prussian blue on wet paper.

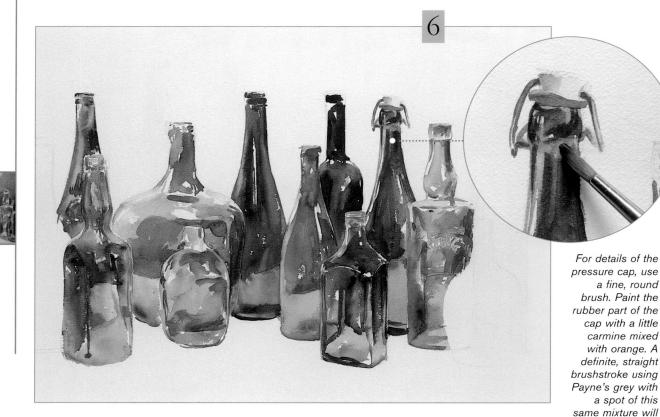

When glass is not smooth, but shaped or stamped, it distorts the shapes seen through it. Using the same mix of ultramarine blue and orange as in the last step, finish the transparent neck of the bottle. A very wet brush will produce the pale tones desired. A little dripping and blurring does not matter as long as the outlines of the bottle appear definite and sharp.

Use an orange ochre for the base of the table. While the wash is wet, add new brushstrokes of the same ochre intensified by the addition of sienna and a bit of carmine. These new colours, painted on a wet surface, meld with the background and produce somewhat blurry outlines.

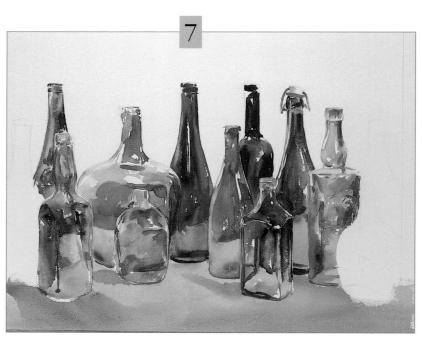

reproduce its

metal hinge.

shadow and the

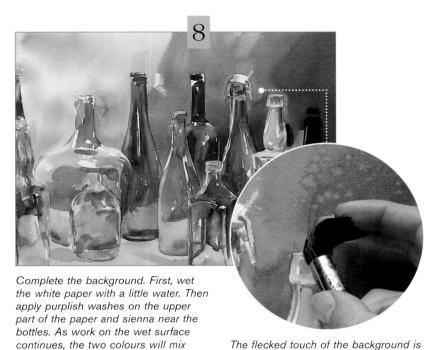

unevenly. Paint this area with a wash

brush.

Tip

When painting with watercolours, reflections on glass can be rendered by keeping parts of the paper free of paint.

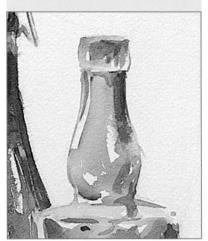

The flecked touch of the background is created by rubbing the bristles of the brush with the fingertips, spraying colour onto the paper, adding variety to an otherwise flat field of colour.

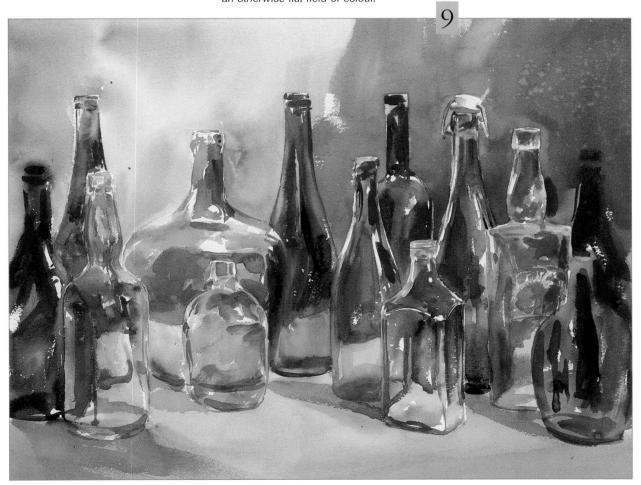

Here you can see the finished painting. It features well-defined volumes and an endless variation of highlights that are achieved by keeping parts of the paper white, creating a sensation of volume, intensity of colour and pictorial density.

We can now see how the previous exercise, painted by a professional artist, is reproduced by art students who are still learning their craft. The students have painted the same objects, though framing them differently or in some cases simply shifting their perspective. The different ways of working and different interpretations of the subject have produced different – and no less interesting – results that are well worth examining. Learning from achievements and successful experiments can stimulate the student and advance the learning process.

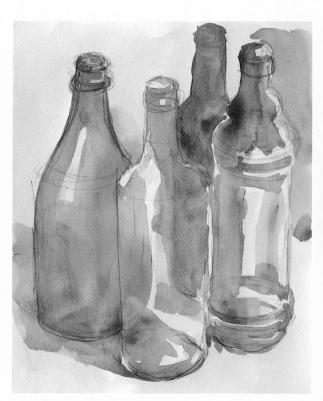

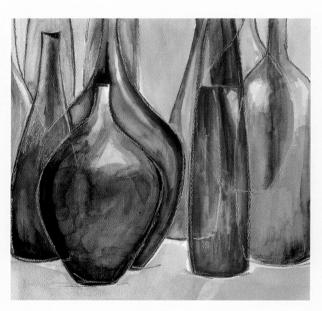

Selecting an unusual point of view or framing a subject in a surprising way is often a successful artistic technique, even when some elements have to be left out of the painting. If the compositional approach is accompanied by interpretive inspiration, it can result in a painting like the one seen here, where the denser, darker paint combines with a graphic treatment of the subject with white chalk. Artist: Meritxell Mateu.

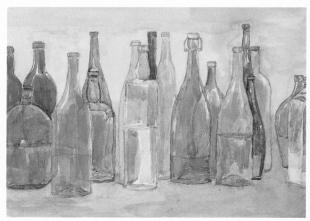

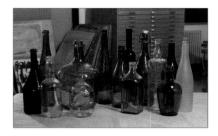

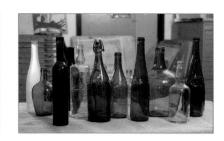

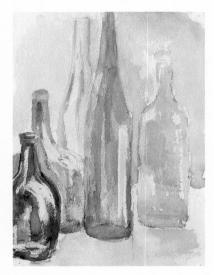

This painting takes maximum advantage of the transparency of watercolour paint to convey the luminosity of the subject. The large amounts of white show the ambient light. Indeed, the whites seem to vibrate in a halo of light. The student achieved this effect by protecting the highlights of the bottle with wax, and using drier brushstrokes in some areas to give the bottles a grainy, flecked effect. Artist: Emilio Calvo.

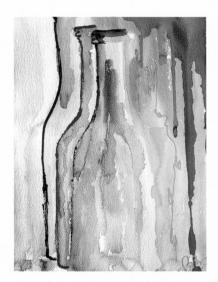

A painting can be an exercise in freedom, taking a highly personal approach to the subject rather than aiming for a literal, figurative representation. Such is the case in this painting, in which the design supports a personal, abstract, expressive character. The washes seem to have run together, but the coloured contours evoke the subject's shape and make it apparent. Artist: Beatriz Reboiras.

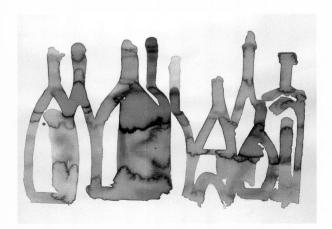

The shapes of the bottles are rendered with a thick, continuous brushstroke that features gradations. The entire composition has a well-formed look that is poetic and suggestive, rather than explicit. The forms are brought together as a result of the colour and the strong drawing, creating a highly evocative work. The painting is constructed as an abstract composition in which the patches of colour and graphic elements represent themselves as much as the subject itself. Artist: Jordi Vila.

WET AND DRY

Representing water with WET and DRY TECHNIQUES

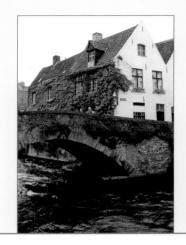

Wet and dry techniques are combined here in a single painting. The dry technique contributes clearly defined brushstrokes, whereas the wet background creates less defined areas and billows of colour. The subject is a rural scene in which the surface of the water and its reflections play the leading role. Rendering reflections with watercolours depends on two essential elements: the background of the composition and the dark paint used for the reflections.

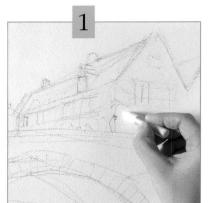

First, using a graphite pencil, draw the main shapes in the subject with sharp lines. Use a wax bar to protect relevant areas on the paper from the paint.

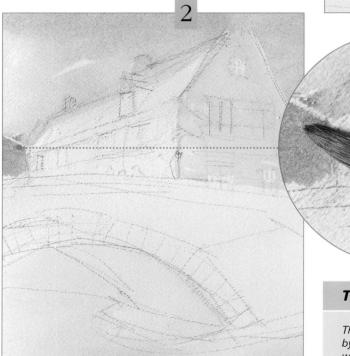

Use a highly transparent violet for the sky and the surface of the water, painting on a dry surface. With brushstrokes outline the shape of the houses and the bridge. The white façade of the house is treated with a very light sienna wash, to avoid the stridency of the unpainted white paper.

Tip

The sections protected by wax leave a rough whitish texture that stands out in the surrounding paint.

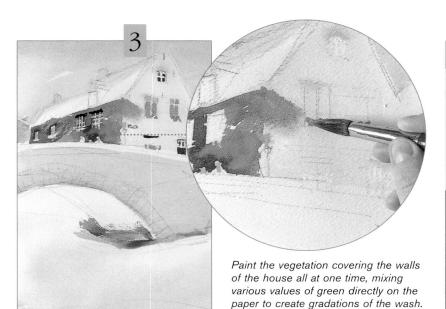

By applying dark washes to the windows while protecting the window frames with wax, the frames can be made to come through in their whiteness. A highly transparent grey wash can be used on the bridge.

When painting with watercolours, it is sometimes advisable to go over the original outlines of the drawing to preserve certain lines and details that should be visible in the final painting.

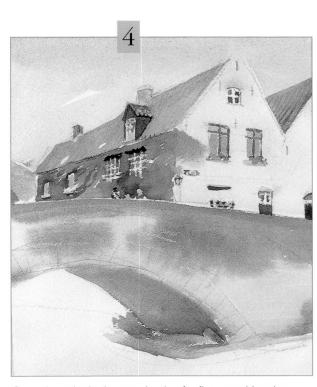

Once the paint is dry, use the tip of a fine round brush to paint the darkest parts of the house and the window frames. After waiting for the wash used on the bridge to dry somewhat, apply green and burnt umber strokes, which will spread, producing an interesting effect. This should be done while the background is still damp but not soaking wet.

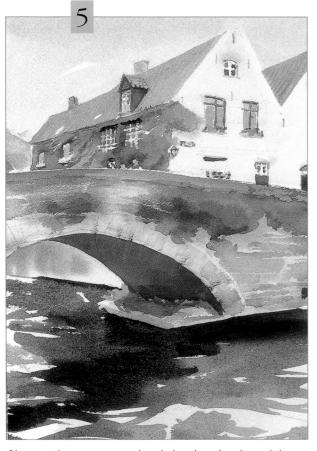

Always paint water somewhat darker than the sky and the architectural elements that it reflects. In this case, begin by painting large Payne's grey areas on a dry surface. Over this, damp wash colours can then be added to create gradations in the wash.

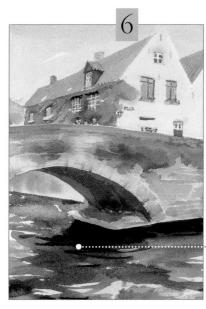

To simulate the constantly moving surface of the water, paint some zigzag reflections with thinner brushstrokes. It is essential to leave small bare spaces for the colour of the paper to show through. These spaces help to recreate the sensation of light reflecting on the water.

Once the dark wash for the water's surface has dried, paint the shadow of the bridge with more intense washes. At the base of the bridge and the area near the bank, the mass of colour should be much darker and denser.

Use strokes that are shorter and farther apart when painting water reflections farther away from the upper area or shore.

To complete the painting, apply violet, greenish-grey brushstrokes to the water. Do this with a brush that is only moderately moist, and wait until the background has dried completely. Leave some space between these wide, undulating and rough-textured strokes, so that the background colour shows through between them. These brushstrokes are what give the water's surface its vitality.

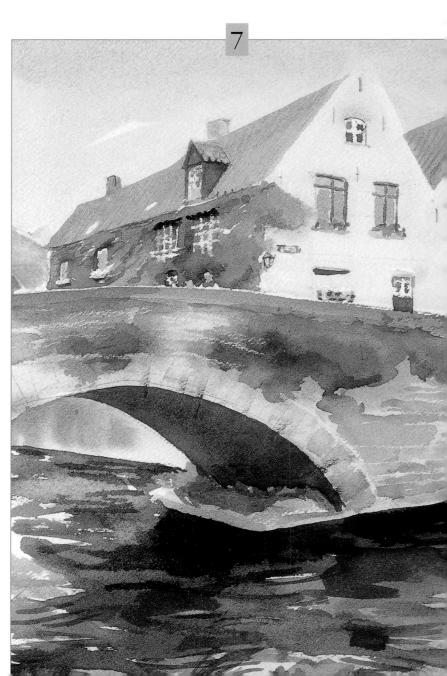

SPONTANEOUS EFFECTS with A WET BRUSH on WET PAPER

In this section we explore the world of possibilities opened up by painting on wet paper. The mixtures that occur in using this technique can produce very special textures and effects. But before using this technique in a painting, it is useful to experiment on a separate piece of paper.

Much of the work of a good watercolour artist consists of planning beforehand, knowing how to preserve white spaces, and learning how to let colours mix on a wet surface.

If we apply a colour and immediately apply another more intense colour on top, the more intense colour overpowers the previous one and tends to cover it.

If, however, we wait a little before applying the second colour, the still-damp yellow stands up to the blue, and a soft green area emerges where the two colours mix.

If we juxtapose different strips of colour on a wet surface, they will tend to spread on top of each other, creating dramatic gradations and mixes.

By painting a strip of colour in the upper area of the paper with a wet brush and then tilting the paper, the colour will run down, forming a gradation as it migrates.

Areas of colour can be juxtaposed on wet paper and allowed to mix. This technique is often used to paint groups of flowers.

If the paper is too wet, the brushstrokes will tend to dissolve and disappear.

If we wait for the paper to absorb some of the wetness, the brushstrokes will expand, forming striking gradations.

If we wait a few minutes so that the paper absorbs a good amount of the water, the brushstroke will remain clearly visible, though the edges will spread and will not be sharply defined.

LANDSCAPE with

LANDSCAPE with ATMOSPHERE

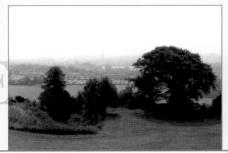

There are various ways of recreating on paper the third dimension of a landscape. In this exercise the focus is on two ways of rendering the effect of the space between the viewer and the more distant parts of the landscape: by taking advantage of the fact that distant objects fade in colour as their distance from the viewer increases; and by a contrasting foreground, giving the viewer a frame of reference with which to relate to the size of shapes farther in the distance.

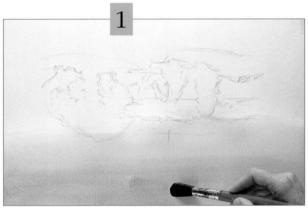

First, make a rough pencil sketch. Then turn it upside down and begin painting the sky in a gradation of colour that moves from yellow near the horizon to violet in the upper part.

Paint the most distant planes of the scene with violet washes that intensify as you move down the paper. Blank spaces can be left between the planes, so that the different tones will not overlap too much.

Render the horizon with a violet wash, working on the wet paper. This will produce the undefined, misty effect seen here, as though the lines and shapes were out of focus.

Tip

The backgrounds of landscapes, such as skies, are generally painted on wet paper.
Gradations and mixes of colour created in this way can be extremely effective in recreating the light produced by the atmosphere.

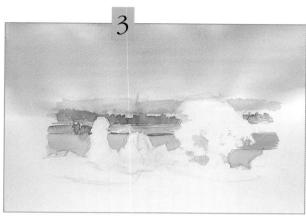

As the eye moves from the far distance to the middle range of the scene, the violet colouration gives way to the real colour of the vegetation, which will be painted with green washes. Note the importance of applying these washes in one pass, to avoid creating discontinuities of colour in the fields.

All that remains is to create a foreground that will produce a sense of depth by providing a contrast with the elements seen in the distance. This can be accomplished by painting the foreground vegetation with colours that are less diluted, more opaque, and thus more intense. To do this successfully, make sure that the background is completely dry before beginning work on the foreground.

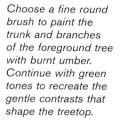

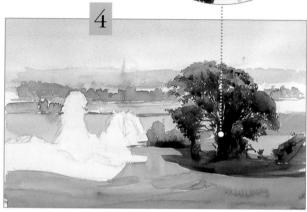

Tip

One way of approaching shadow areas is to define them at the onset. After outlining them with a fine brush, keep them blank during the early stages of the painting.

We complete the darker row of vegetation in the foreground with a variety of earth tones, greens and ochres. Then the exercise will be complete and will have helped enhance your skill in using colour to differentiate the varying depths of foreground, middle ground and background in a scene.

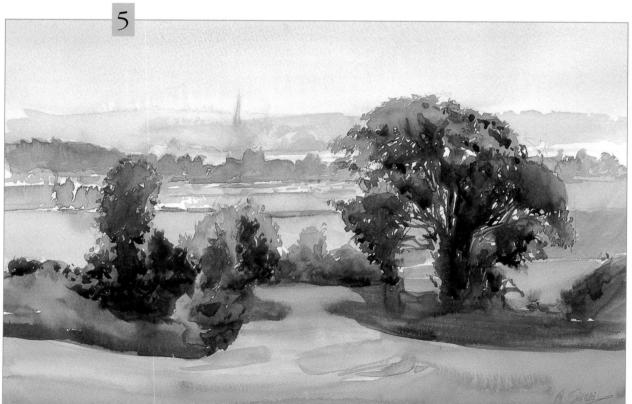

9 6

JOHN CONSTABLE (1776–1837)

A portrait of John Constable.

ew artists have painted and studied nature with as much enthusiasm as the outstanding landscape painter John Constable. The bulk of his work is made up of a large number of watercolours, which exude a vitality that conveys both patient observation and passionate impulse. His treatment of light and colour was very much admired by his Romantic contemporaries, as well as by the impressionists. Many of his ideas have come down to us through a collection of his writings, published in London in 1832 under the title Various Subjects of Landscape. An even more important source of our knowledge on Constable's thinking is the Memoirs of his great friend Leslie, which deal with the artist in a section titled "Painting is a science". Thanks to these publications it is known that

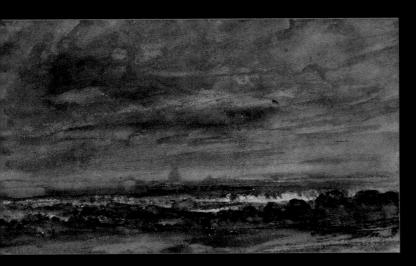

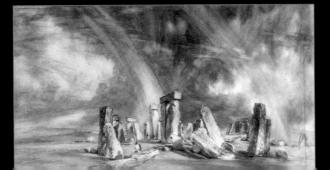

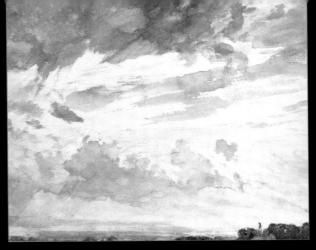

John Constable. Study of Clouds in Hampstead, 1830. Pencil and watercolour, 7.5 × 8.75 in. (19×22 cm) Victoria and Albert Museum, London (United Kingdom).

Constable placed great importance on working *outdoors* and seeking inspiration directly from nature. "The artist should contemplate nature with modest thoughts; a haughty soul would never see it in all of its splendor."

Constable practised what he preached, looking upon nature with the virginal gaze of an unprejudiced mind. "When I sit down to make a sketch from nature, the first thing I try to do is to forget that I have ever seen a picture."

Driven by this passion for immediacy, with a personality inclined to experimentation and a rapid technique capable of capturing on paper the fleeting sensations of an instant - his essential objective -Constable made watercolour a major part of his landscape-sketching tool kit. He devoted a great deal of attention to sky in his landscape work, painting impressive cloud formations and gloomy chiaroscuros that create very definite atmospheres. "It will be difficult," he said, "to name a class of landscape in which the sky is not the keynote, the standard of scale and the chief organ of sentiment." Constable's work reveals intense interest in the most fleeting and ephemeral aspects of the landscape. It constitutes a veritable catalogue of cumulous, cirrus and stratus clouds and their effects on a landscape's light. Constable's landscape is one in constant change - "No two days are alike, nor even two hours" - and every truly original painting is a separate study, governed by its own laws, so that what is right for one work is entirely wrong if transposed to another. What he aspired to convey in his painting was the light, the dew, the breeze, the flowers, the freshness – in short, all of the strikingly transitory phenomena present in the landscape.

John Constable. View of Hampstead, outside London, 1833. Watercolour, 4.5 × 7.5 in. (11×19 cm) Victoria and Albert Museum, London (United Kingdom).

John Constable. Stonehenge, 1836. Watercolour, 15 × 23.5 in. (38 x 59 cm). Victoria and Albert Museum, London (United Kingdom).